Guild Carol Book

Seven congregational carols

Seven unaccompanied carols

by Andrew Henderson

ORARE MUSIC

ORARE MUSIC

Publishing house, record label, choir

www.oraremusic.com

First published 2013. No part of this publication may be reproduced, stored in a retrieval system, or transmitted, in any form or by any means, without the prior permission in writing of Andrew Henderson.

Permission to perform the works in this anthology in public (except in the course of divine worship) should normally be obtained from the Performing Right Society (PRS), 29/33 Berners Street, London W1T 3AB or its affiliated Societies in each country throughout the world, unless the owner or occupier of the premises being used holds a licence from the Society.

Permission to make a recording must be obtained in advance from the Mechanical Copyright Protection Society, Ltd., (MCPS), Elgar House, 41 Streatham High Road, London SW16 1ER, or its affiliated Societies in each country throughout the world.

ISBN 978-1-291-64996-3

Contents

Congregational Carols

Parts for brass quintet are available for these carols. Visit www.oraremusic.com for full details.

Once in royal David's city	1
It came upon the midnight clear	9
In the bleak midwinter	16
O little town of Bethlehem	26
While shepherds watched	34
O come, all ye faithful	41
Hark! the herald-angels sing	52

Unaccompanied Carols

There is no Rose of such virtue	58
I sing of a maiden	62
Rejoice Lordings	66
Ding! Dong! merrily on high	70
The Cherry Tree Carol	76
Longfellow's Carol	80
Gaudete	88

Once in royal David's city

C.F. Alexander (1818-1895)

H.J. Gauntlett (1805-1976)
arr. Andrew Henderson (b1984)
after A.H. Mann (1850-1929)

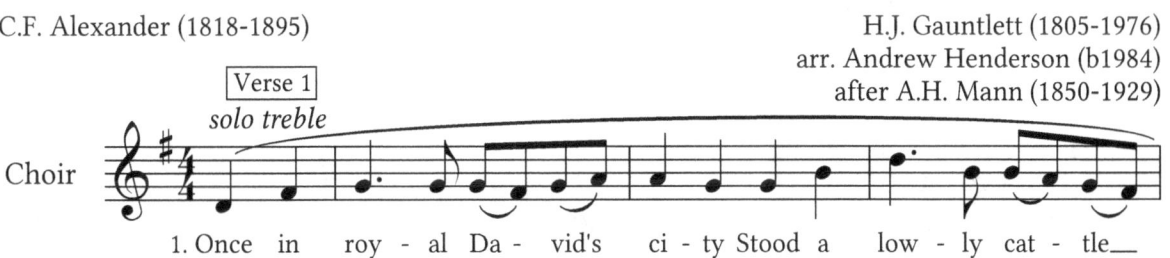

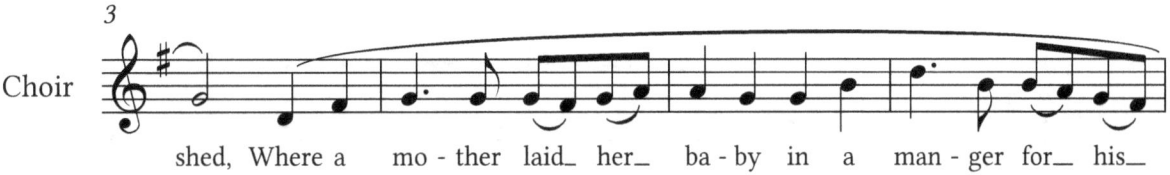

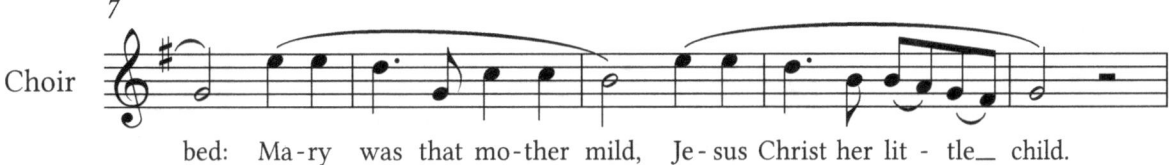

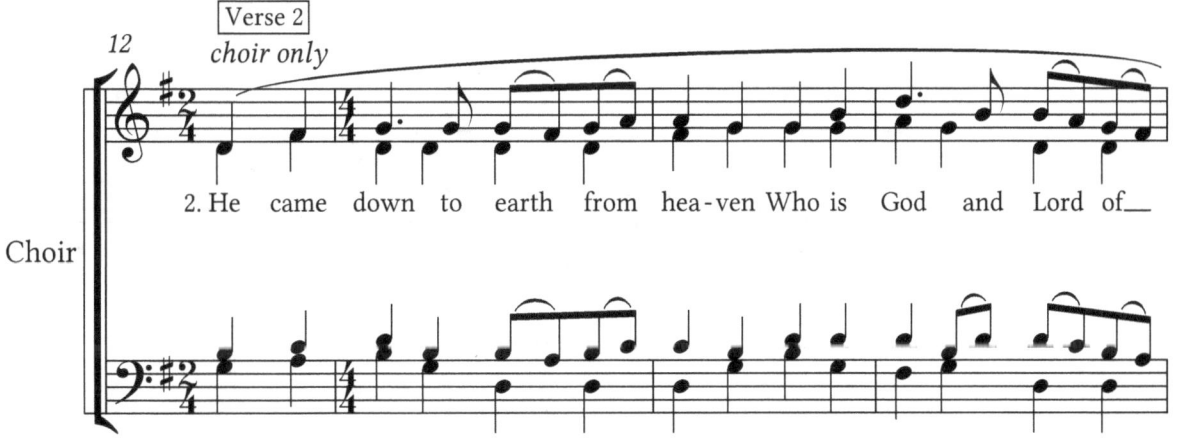

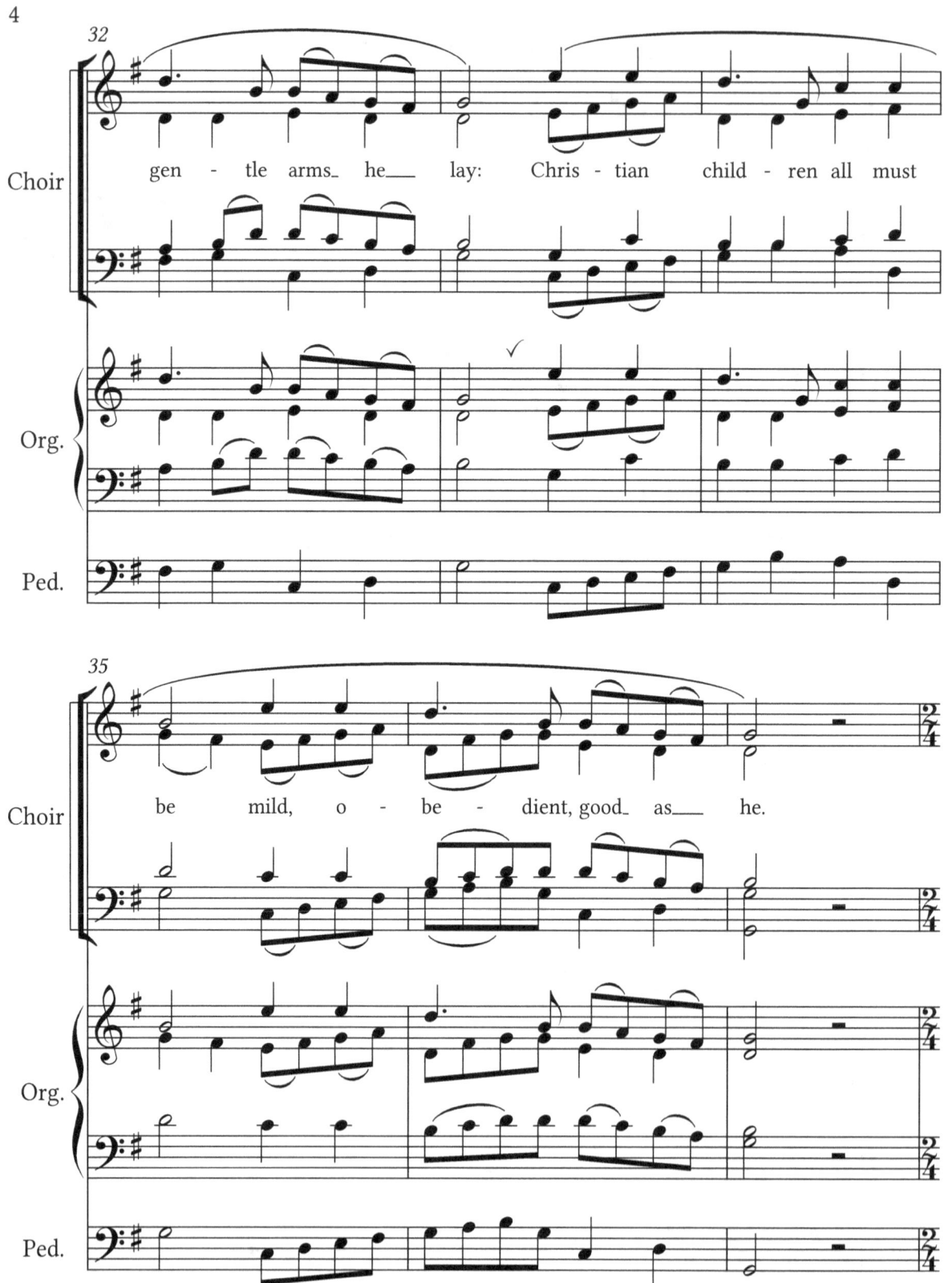

Verse 4

4. And our eyes at last shall see him, Through his own redeeming love, For that child so dear and gentle is our Lord in heav'n a-

bove; And he leads his child-ren on to the place where he___ is___ gone.

Verse 5
Slightly slower

alti, tenori, bassi

5. Not in that poor low-ly sta-ble, With the o-xen stand-ing by, We shall see him; but in hea-ven, Set at

5. Not in that poor low-ly sta-ble, With the o-xen stand-ing by, We shall see him; but in hea-ven, Set at

Slightly slower

It came upon the midnight clear

E.H. Sears (1810-1876)

Traditional English tune
arr. Andrew Henderson (b1984)
after Arthur Sullivan (1842-1900)

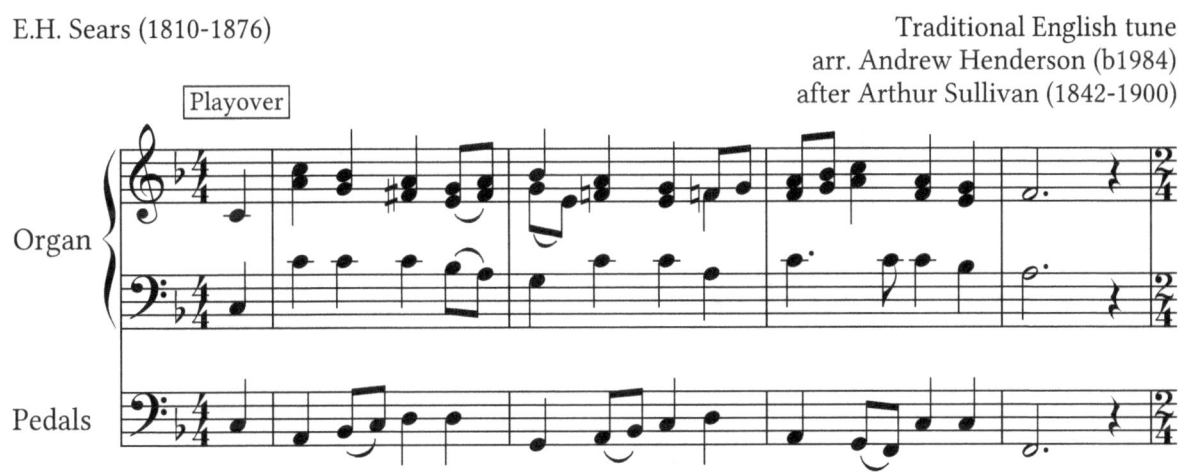

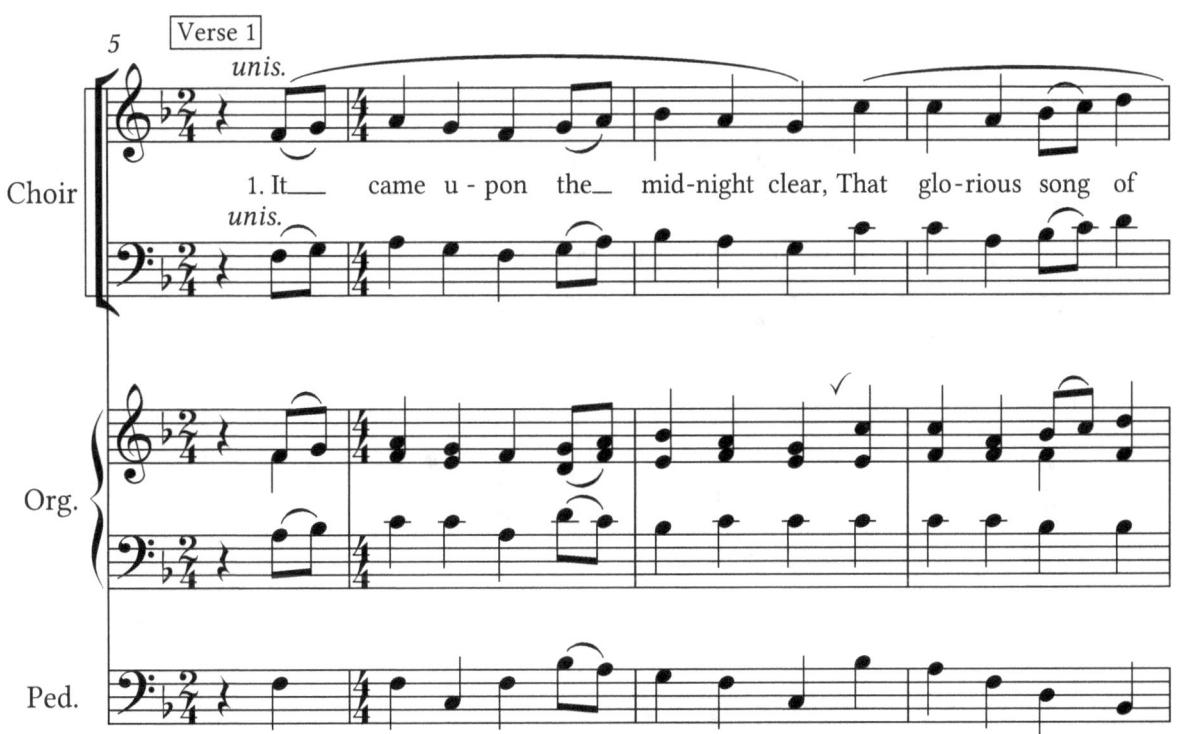

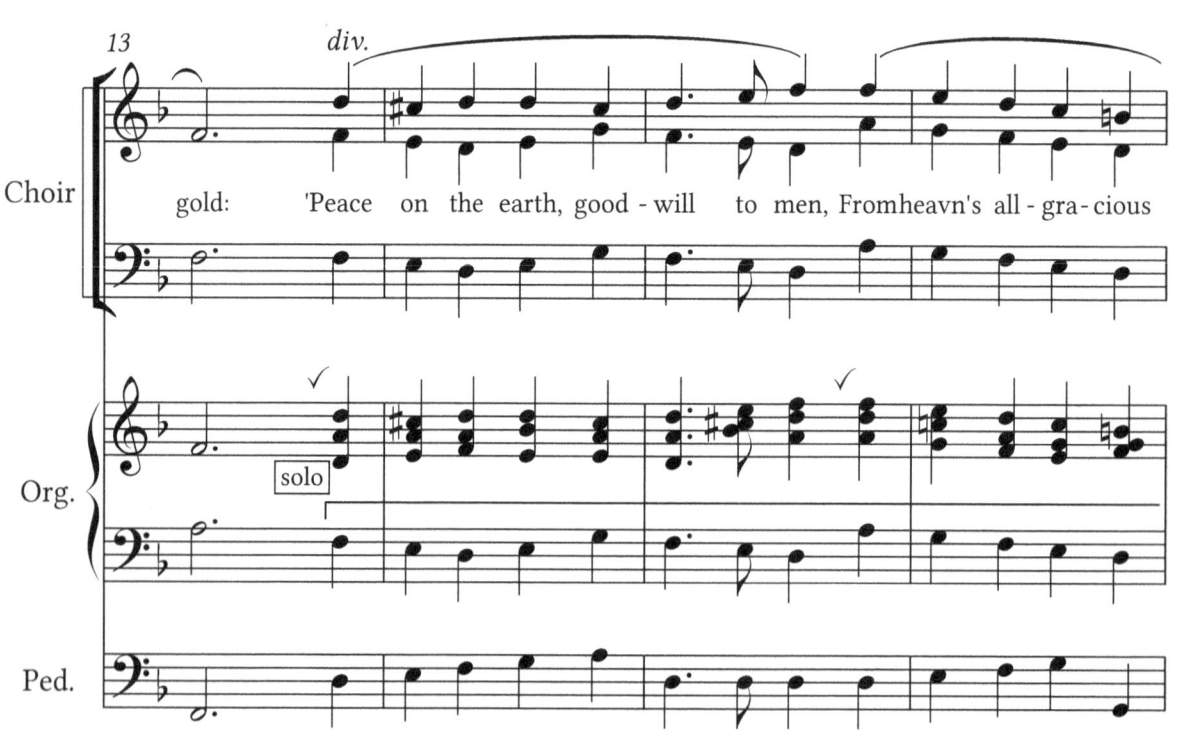

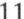

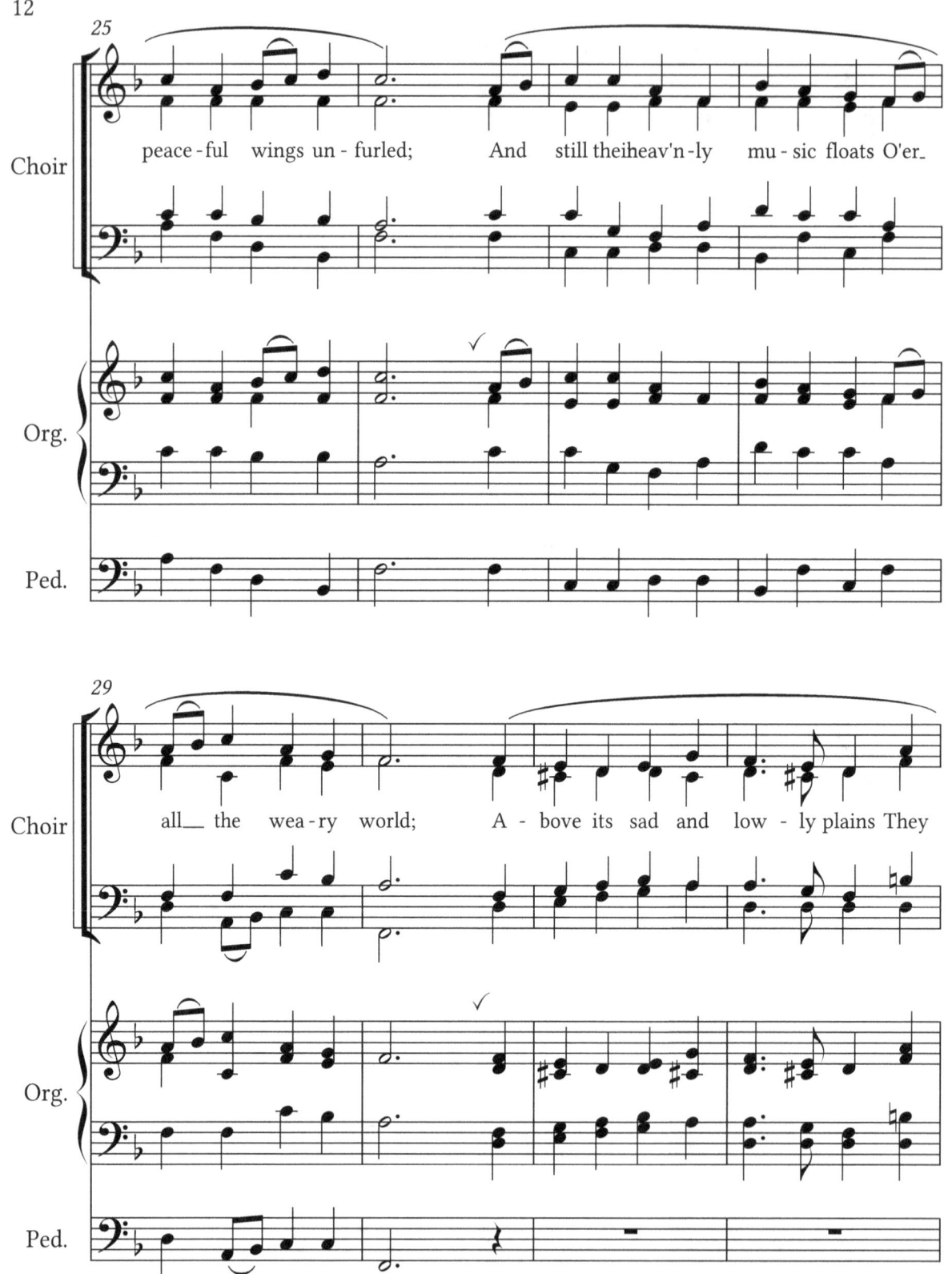

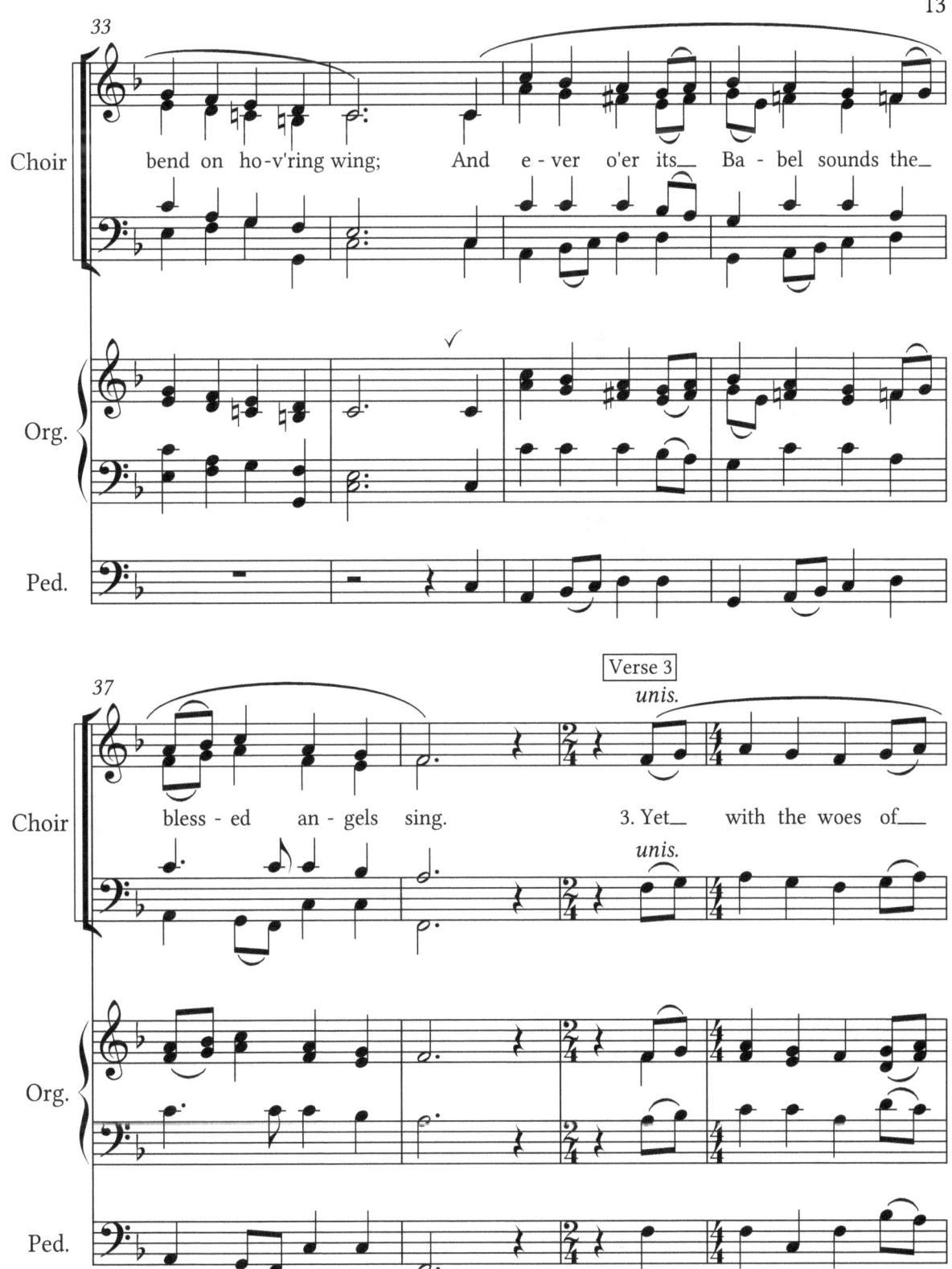

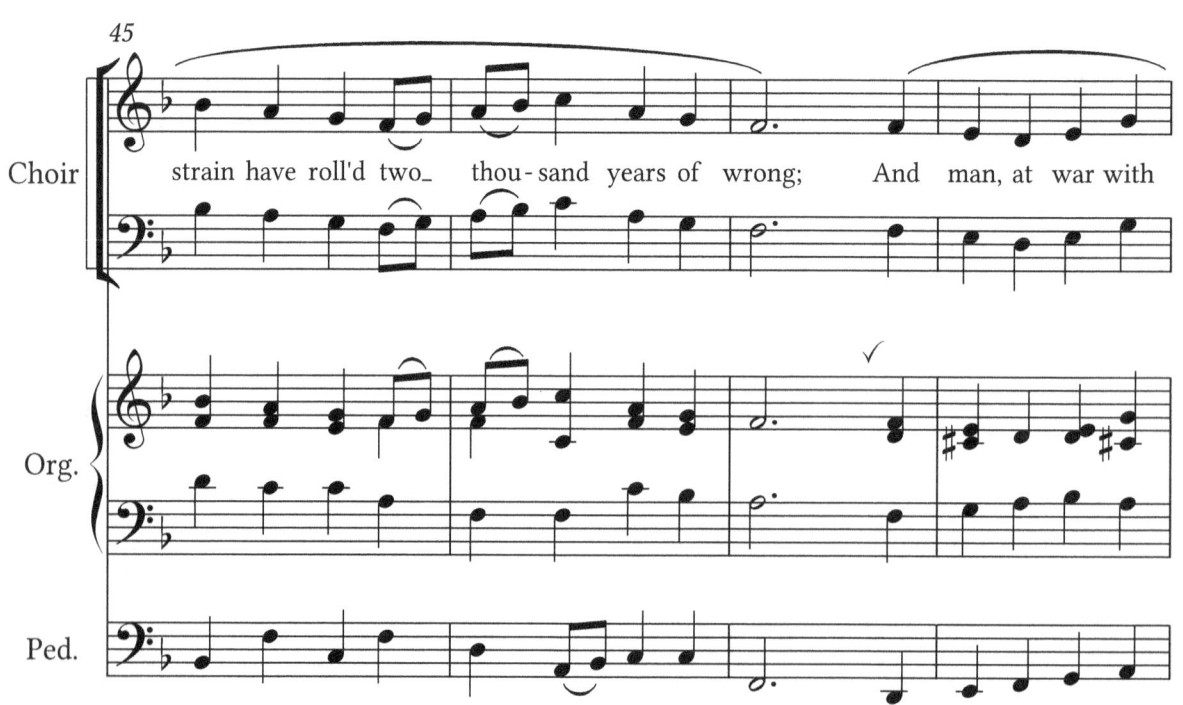

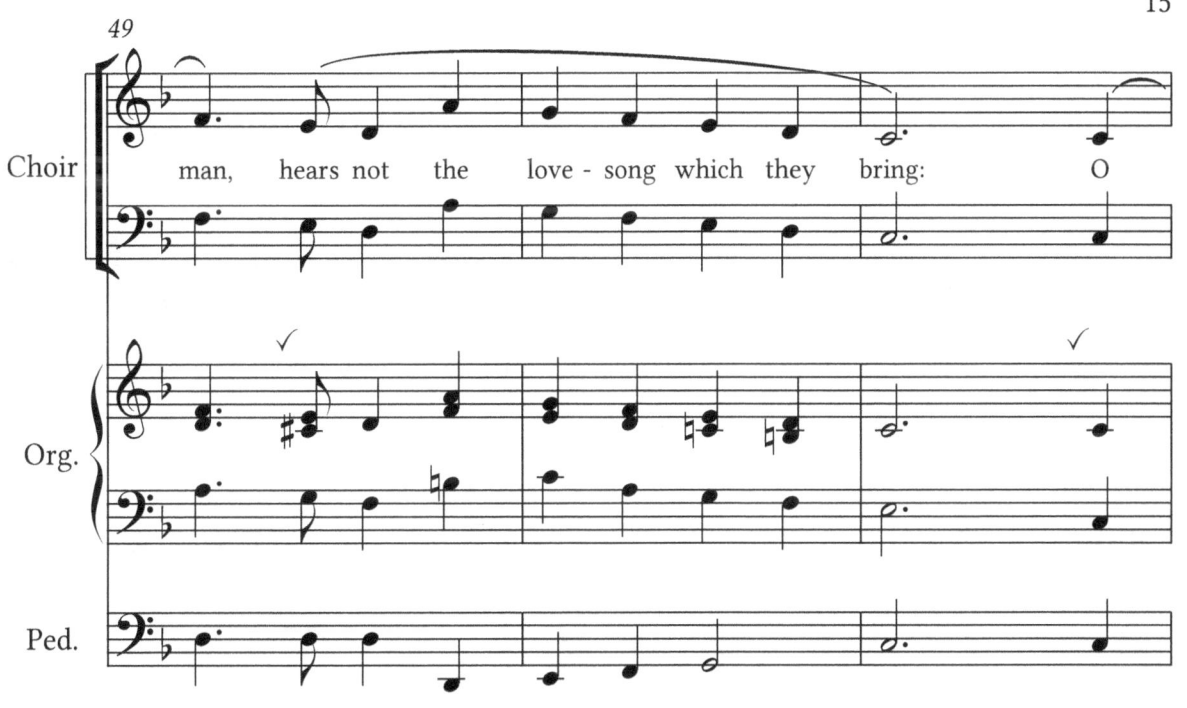
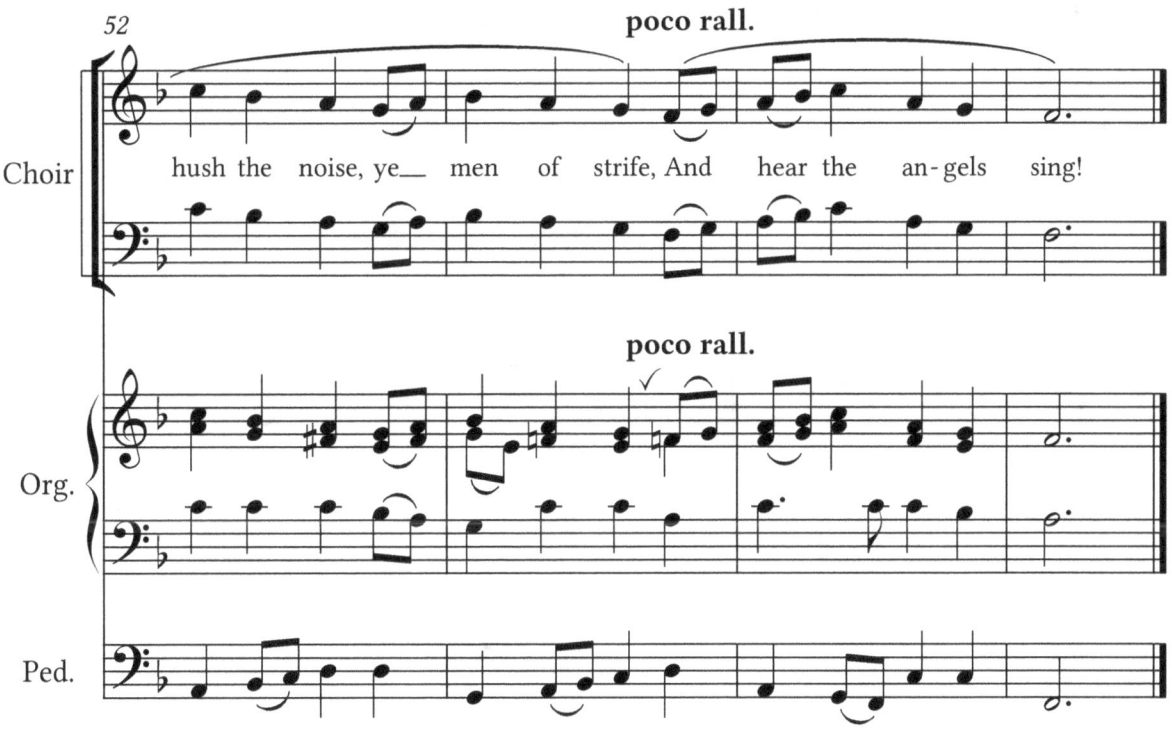

In the bleak midwinter

Christina Rossetti (1830-94)

Gustav Holst (1874-1934)
adapted and arr. Andrew Henderson (b1984)

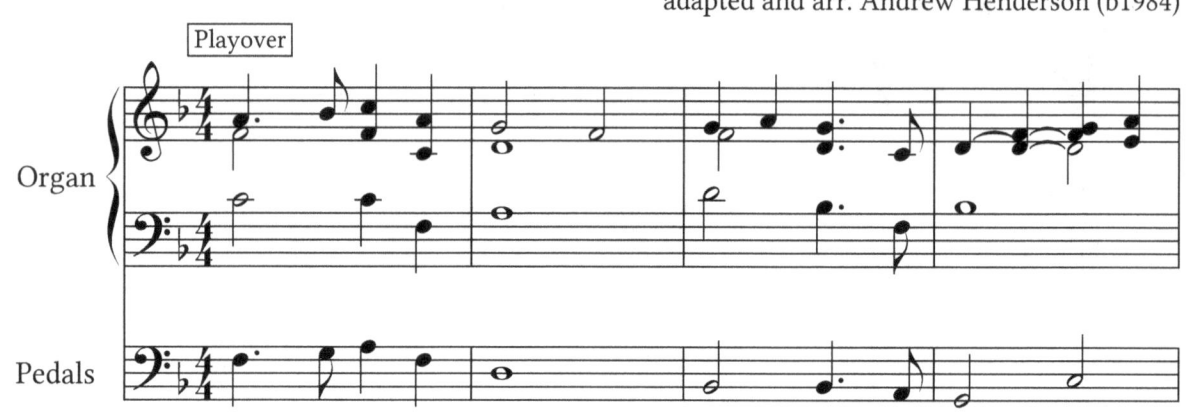

1. In the bleak mid - win - ter fro - sty wind made moan,

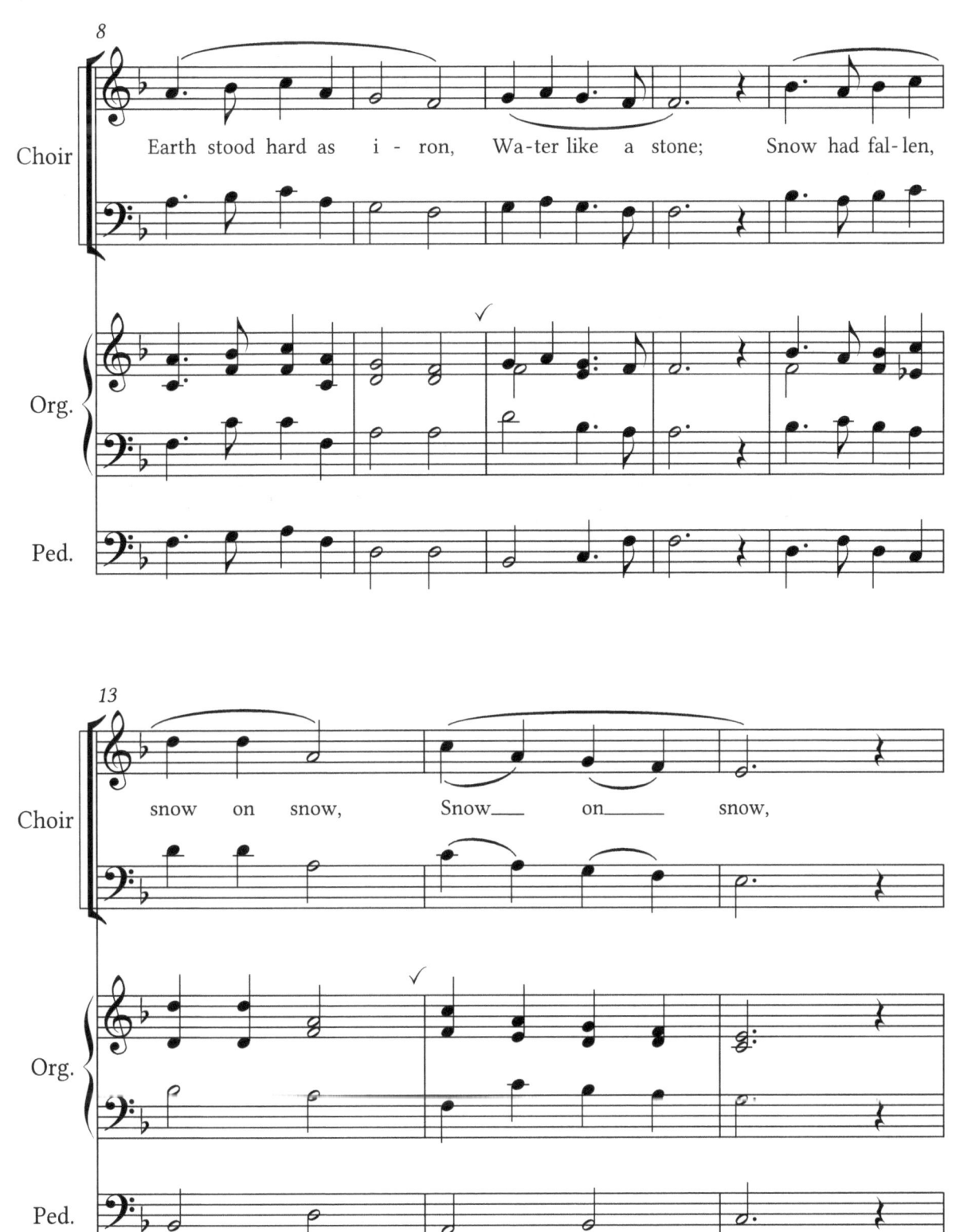

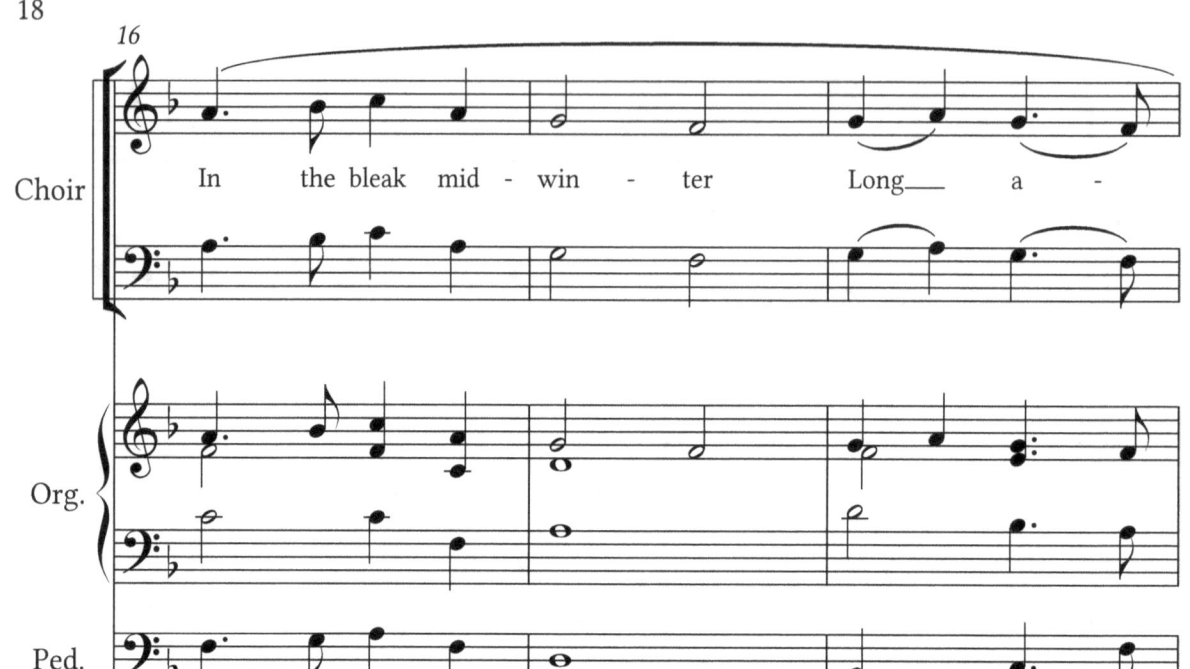

go. 2. Our

Verse 2

God, Heav'n can-not hold him Nor earth su-stain;

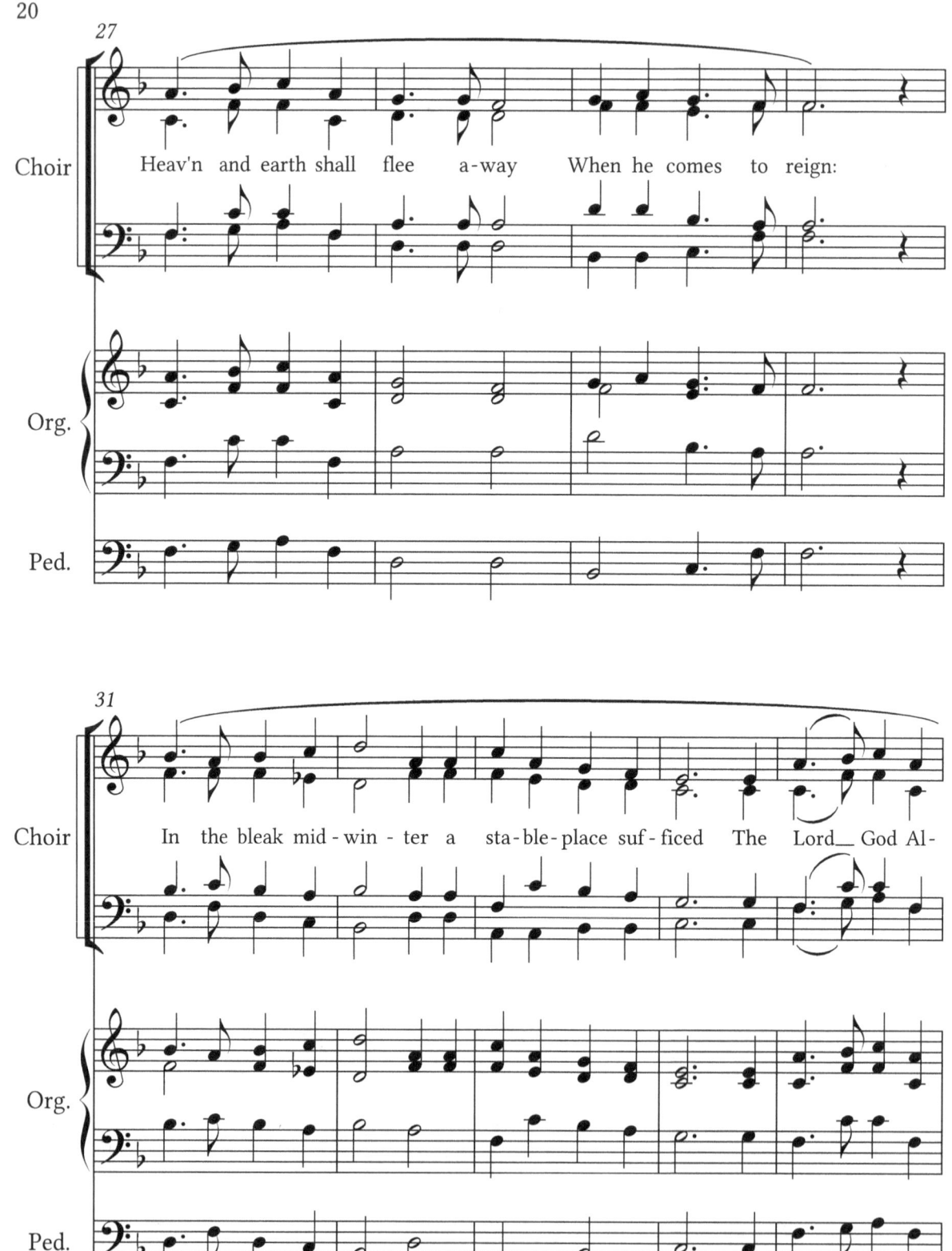

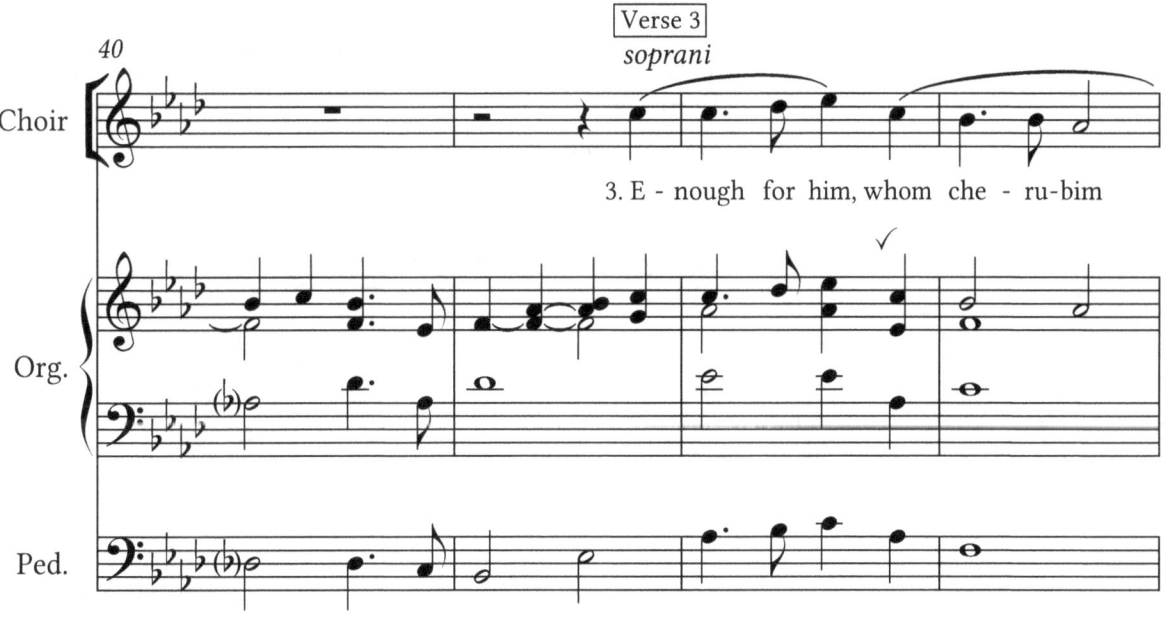

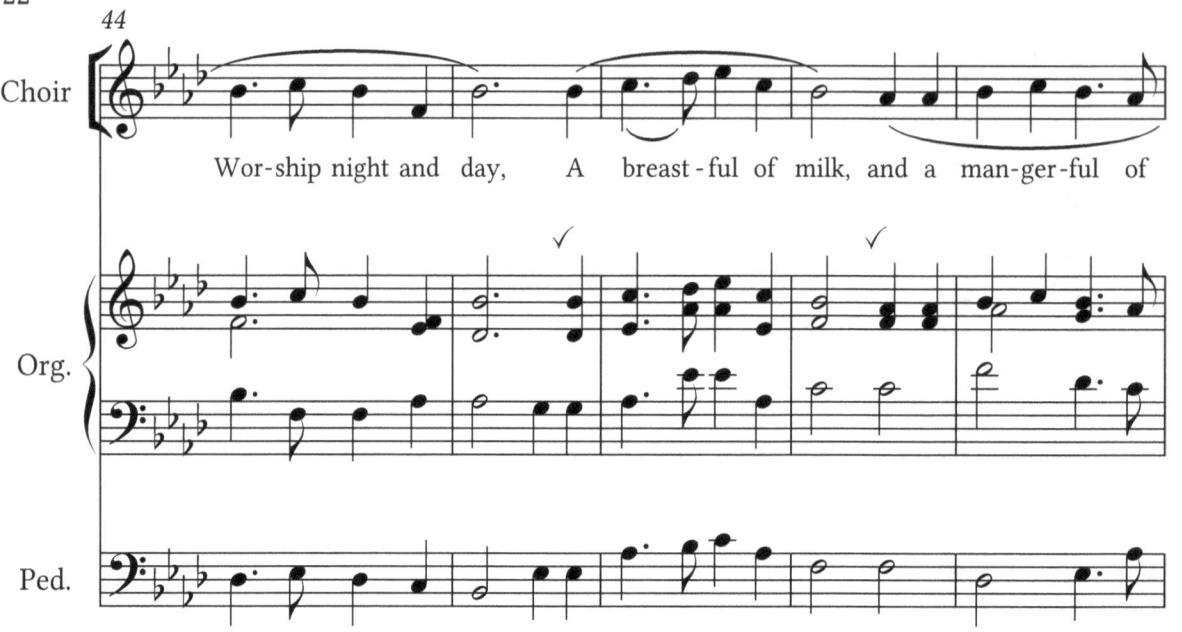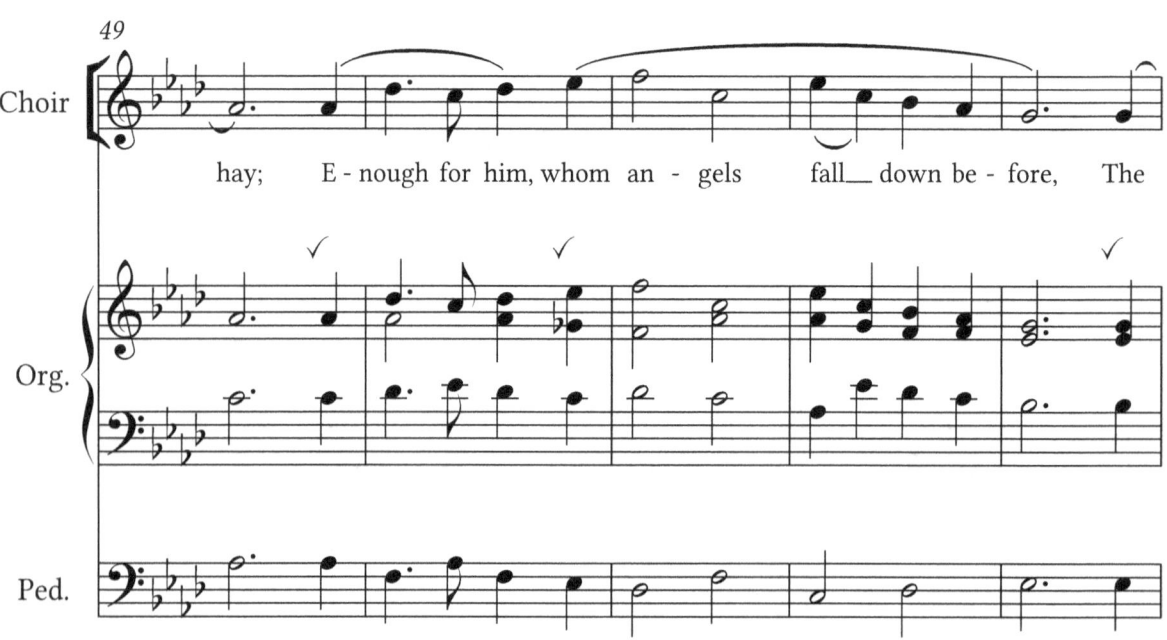

ox and ass and ca - mel which a - dore.

allargando

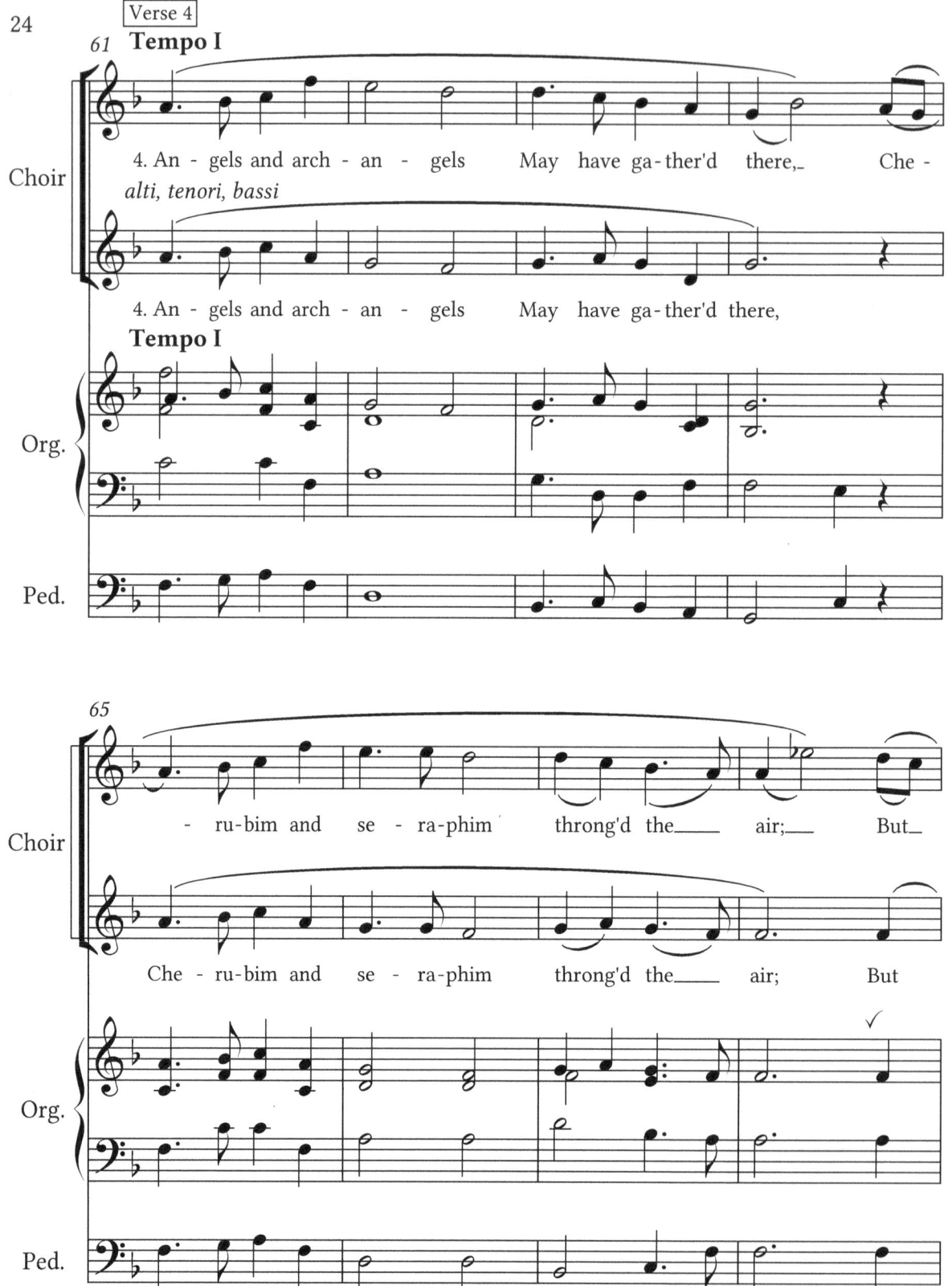

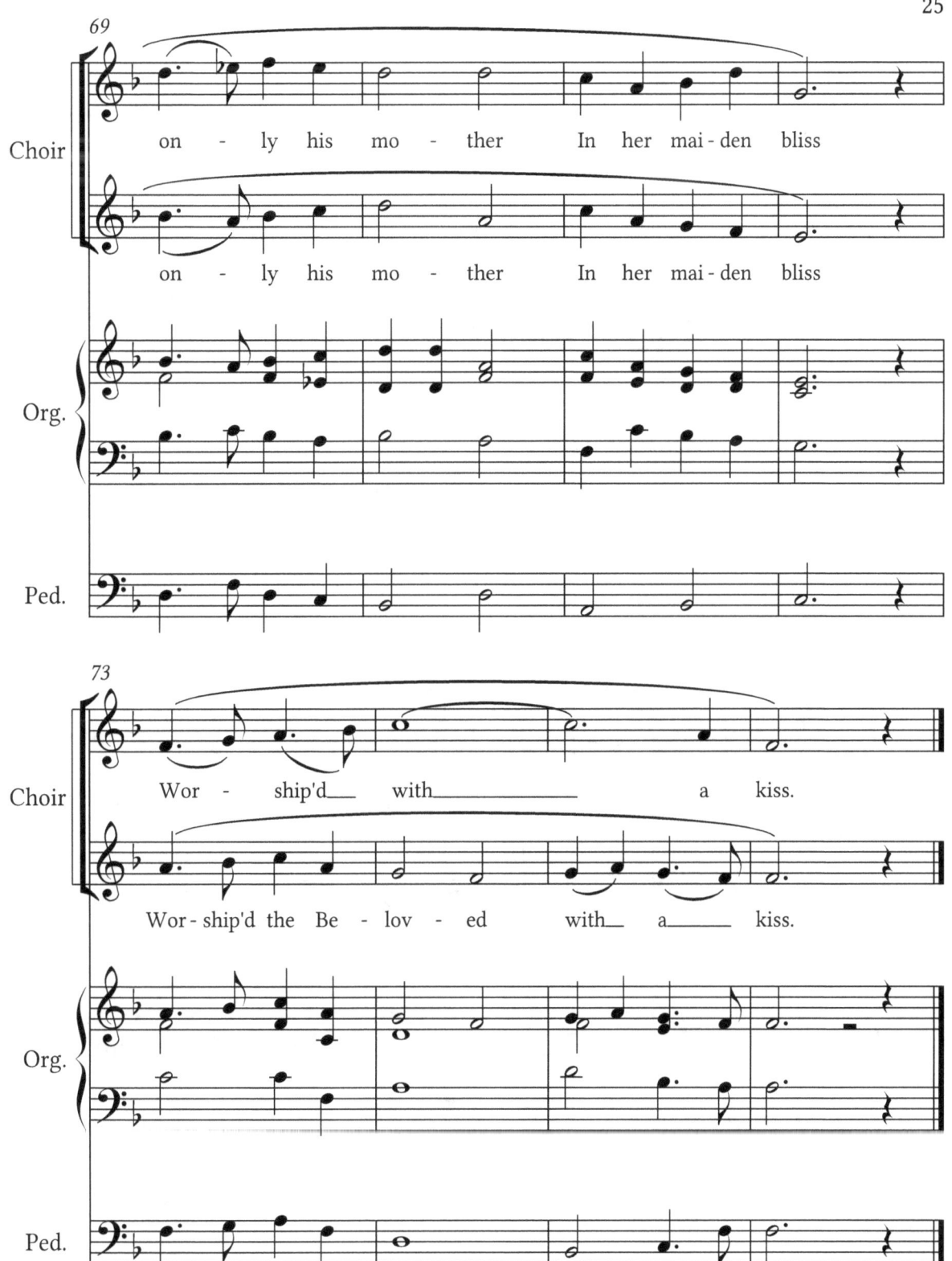

O little town of Bethlehem

Phillips Brooks (1835-93)

English traditional melody
arr. Andrew Henderson (b1984)
after Ralph Vaughan Williams (1872-1958)

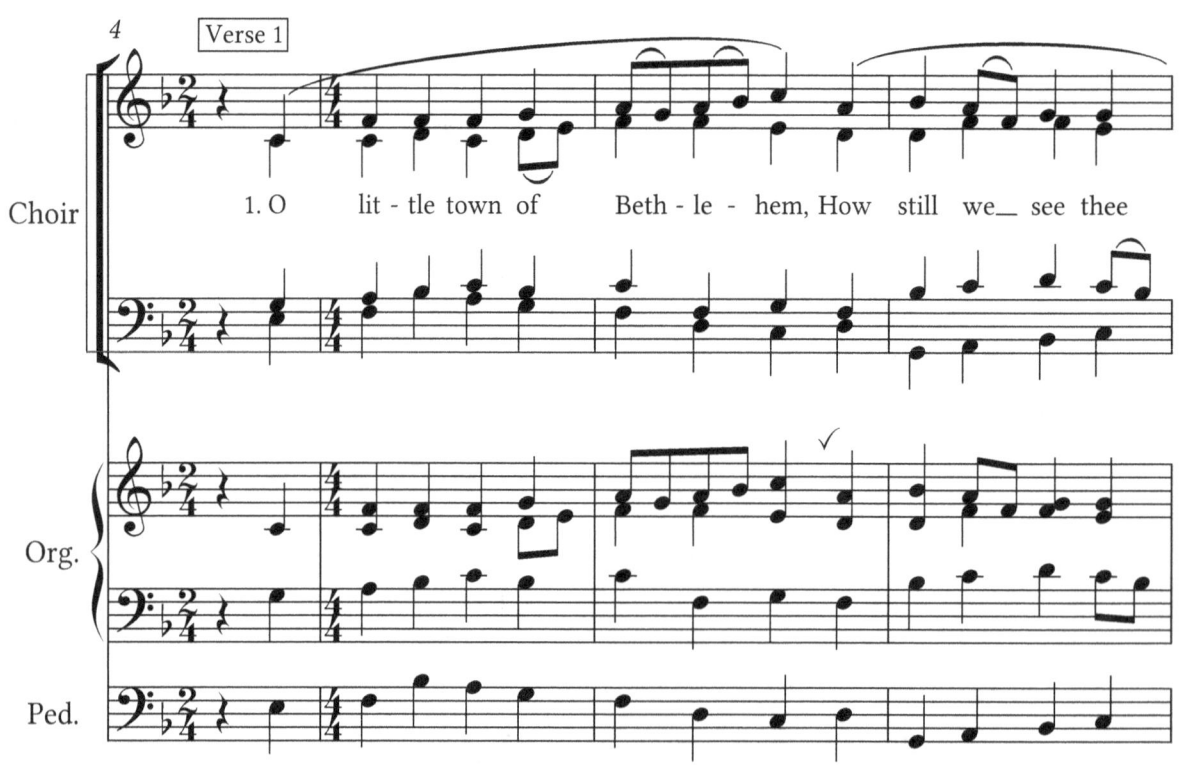

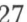

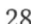

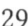

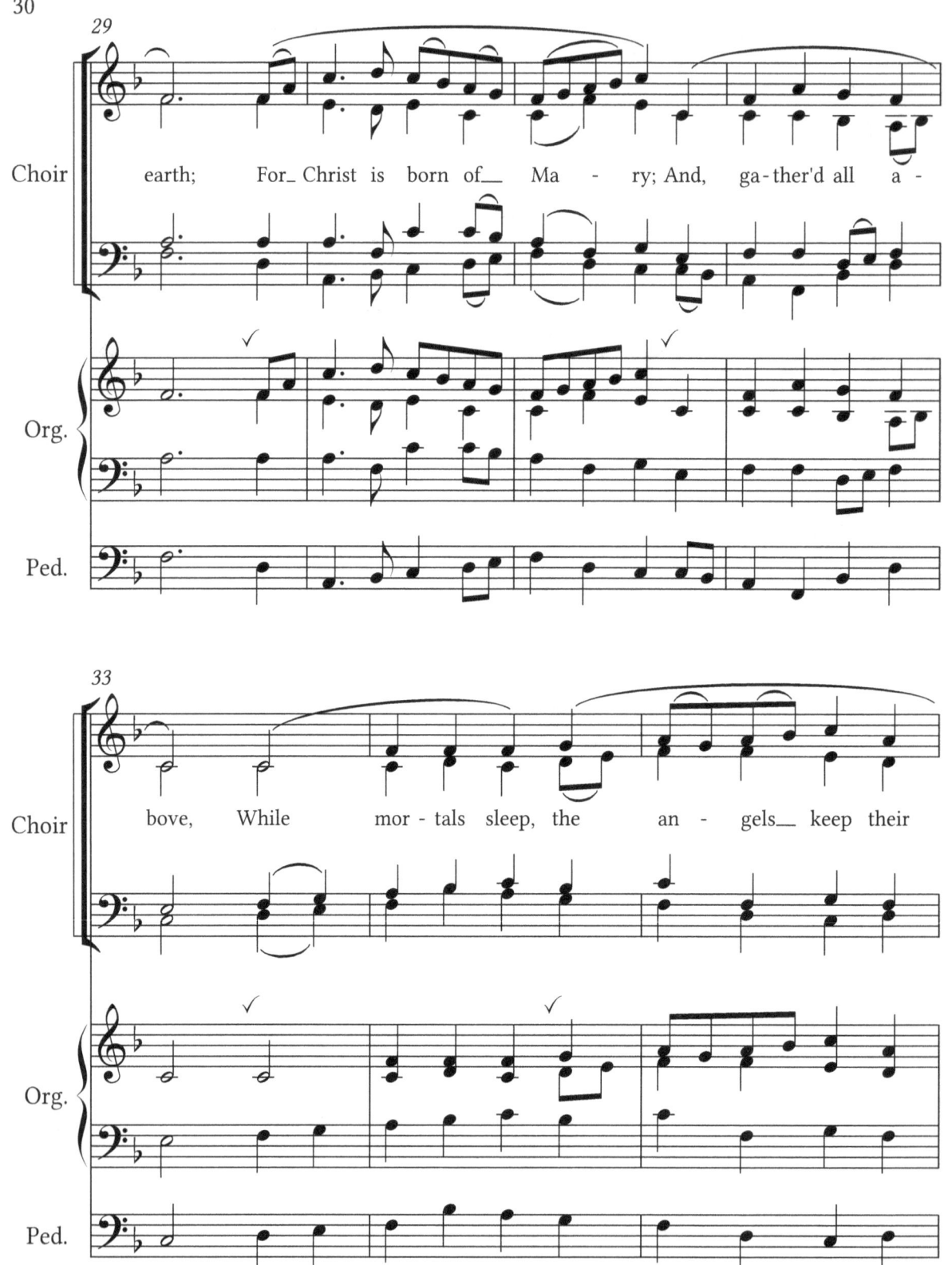

While Shepherds Watched

Nahum Tate (1652-1715)

arr. Andrew Henderson (b1984)
from Este's Psalter (1592)
after Christopher Tye (c1505-c1572)

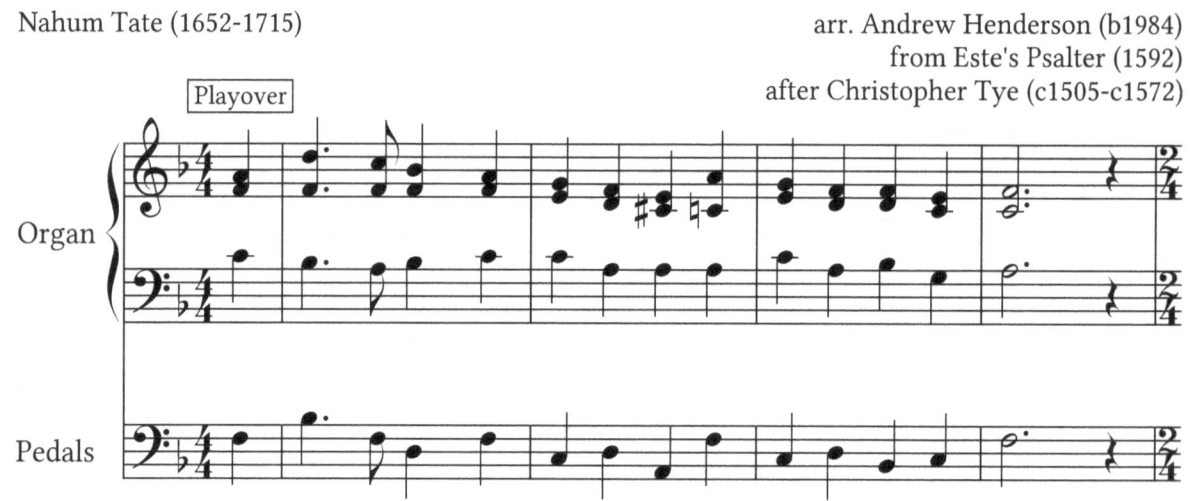

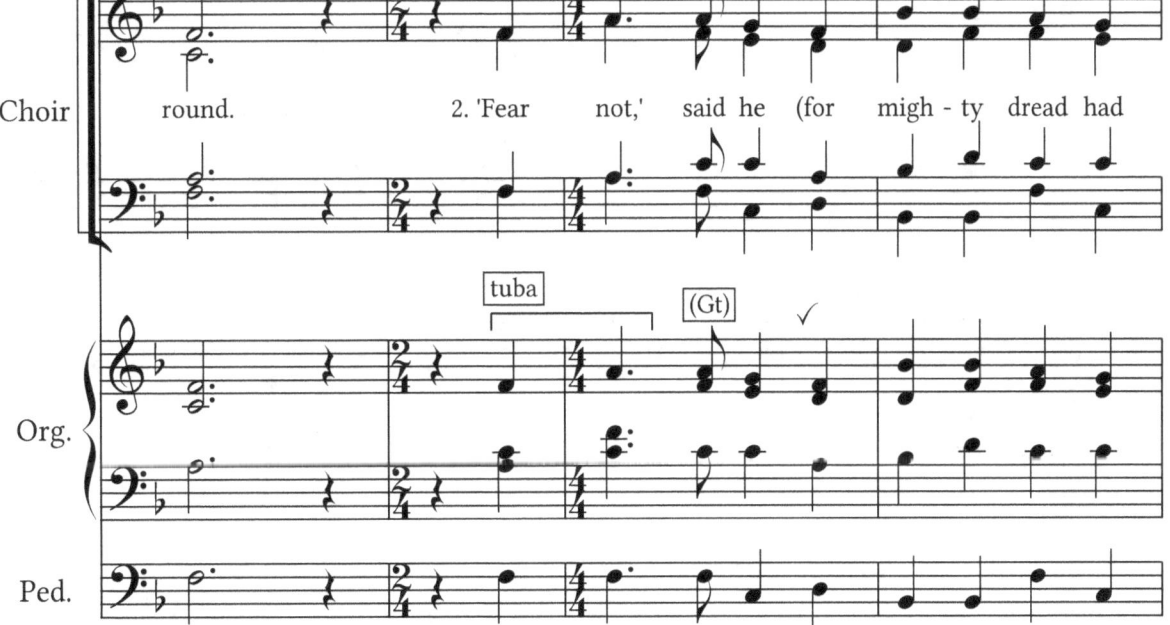

Choir: seiz'd their trou-bled mind); 'Glad tid-ings of great joy I bring to you and all man-kind.

[tuba]

Verse 3 *unis.*

3. 'To you in Da-vid's town this day Is

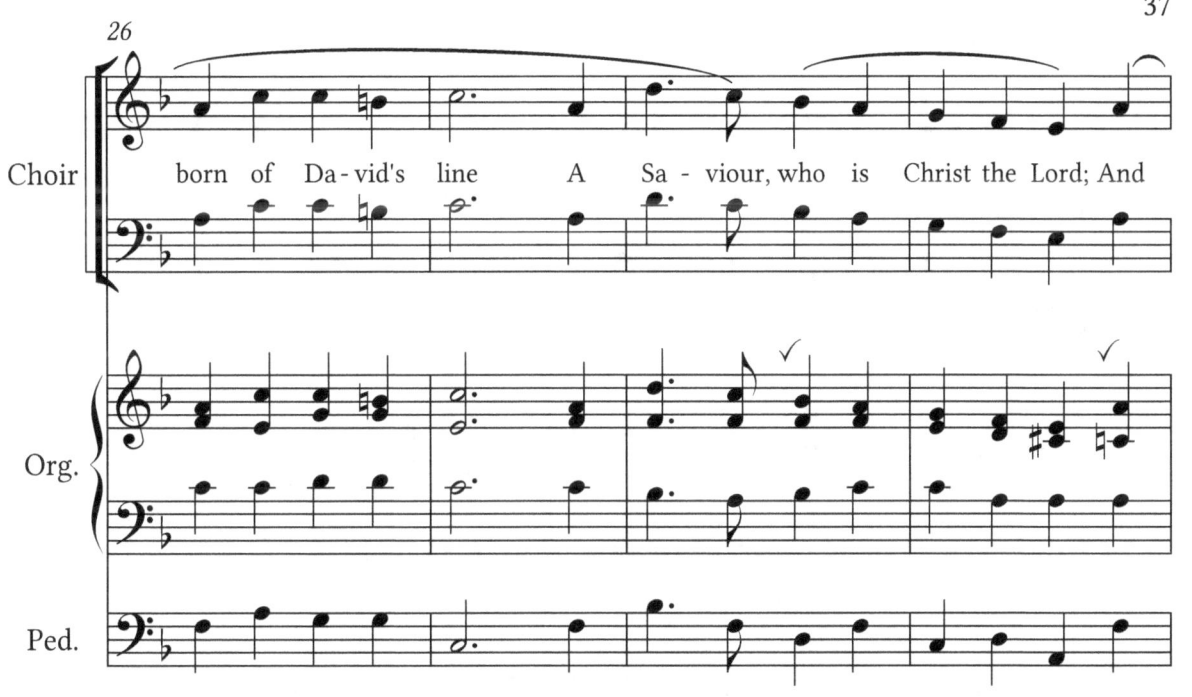

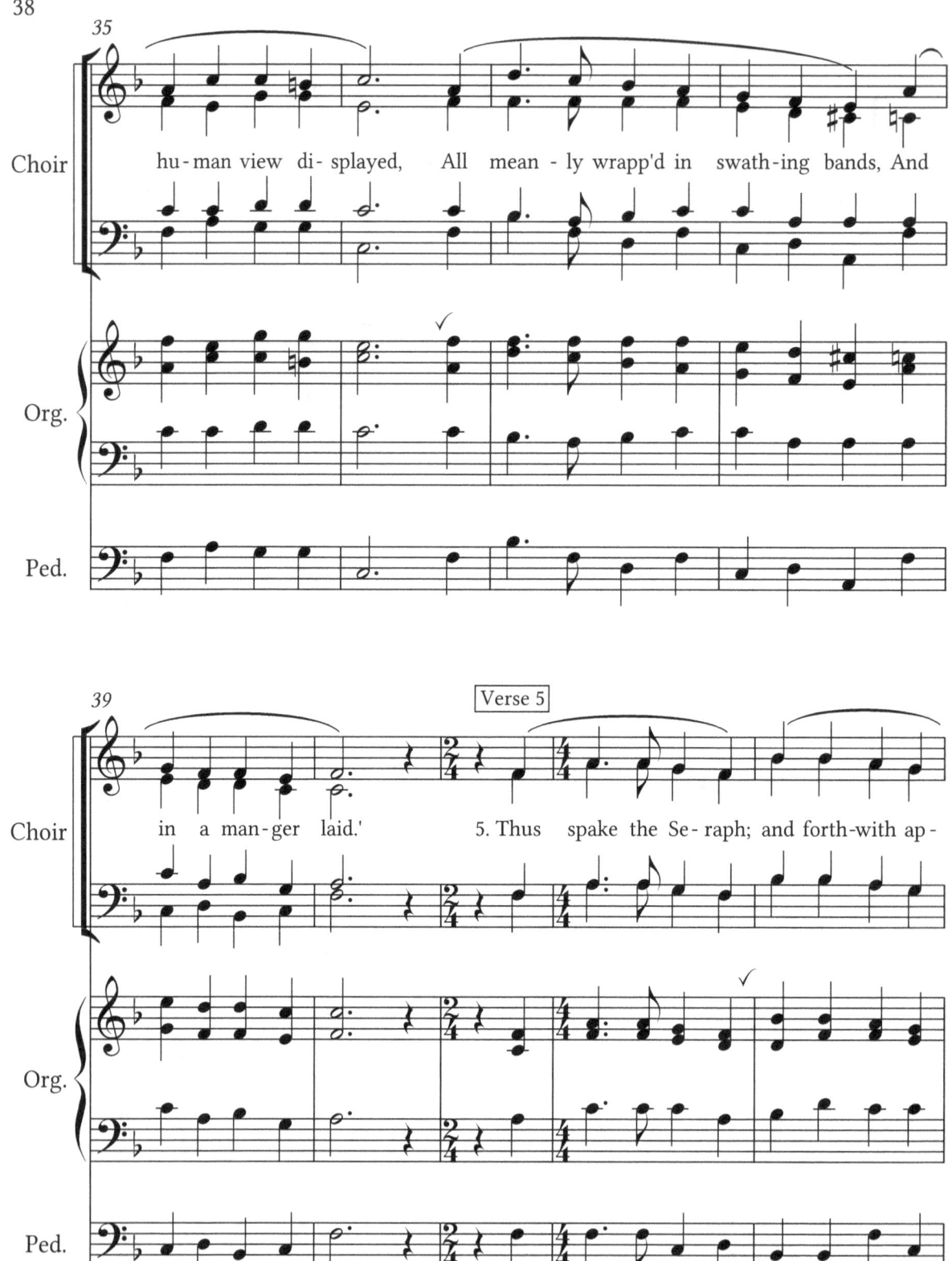

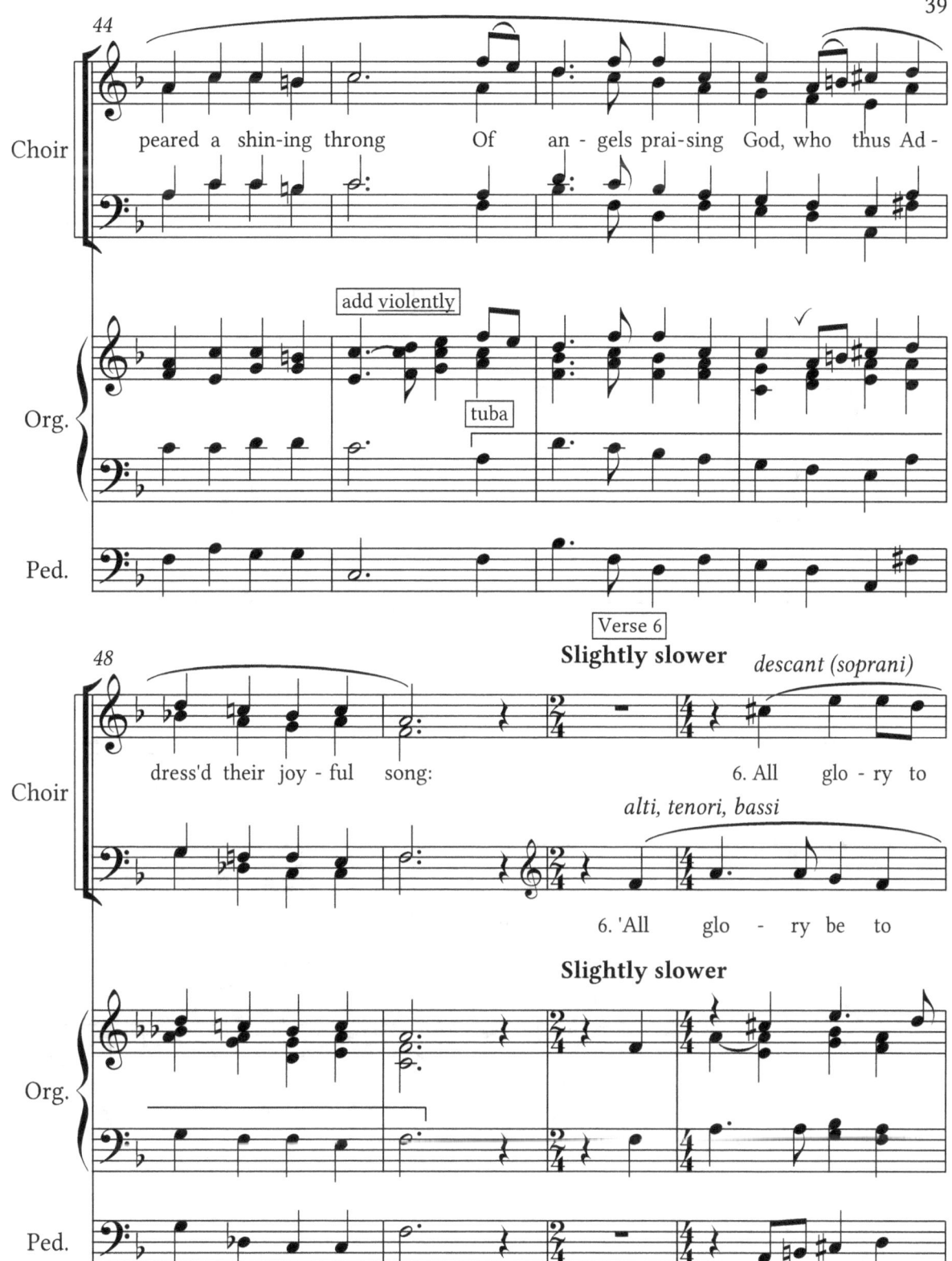

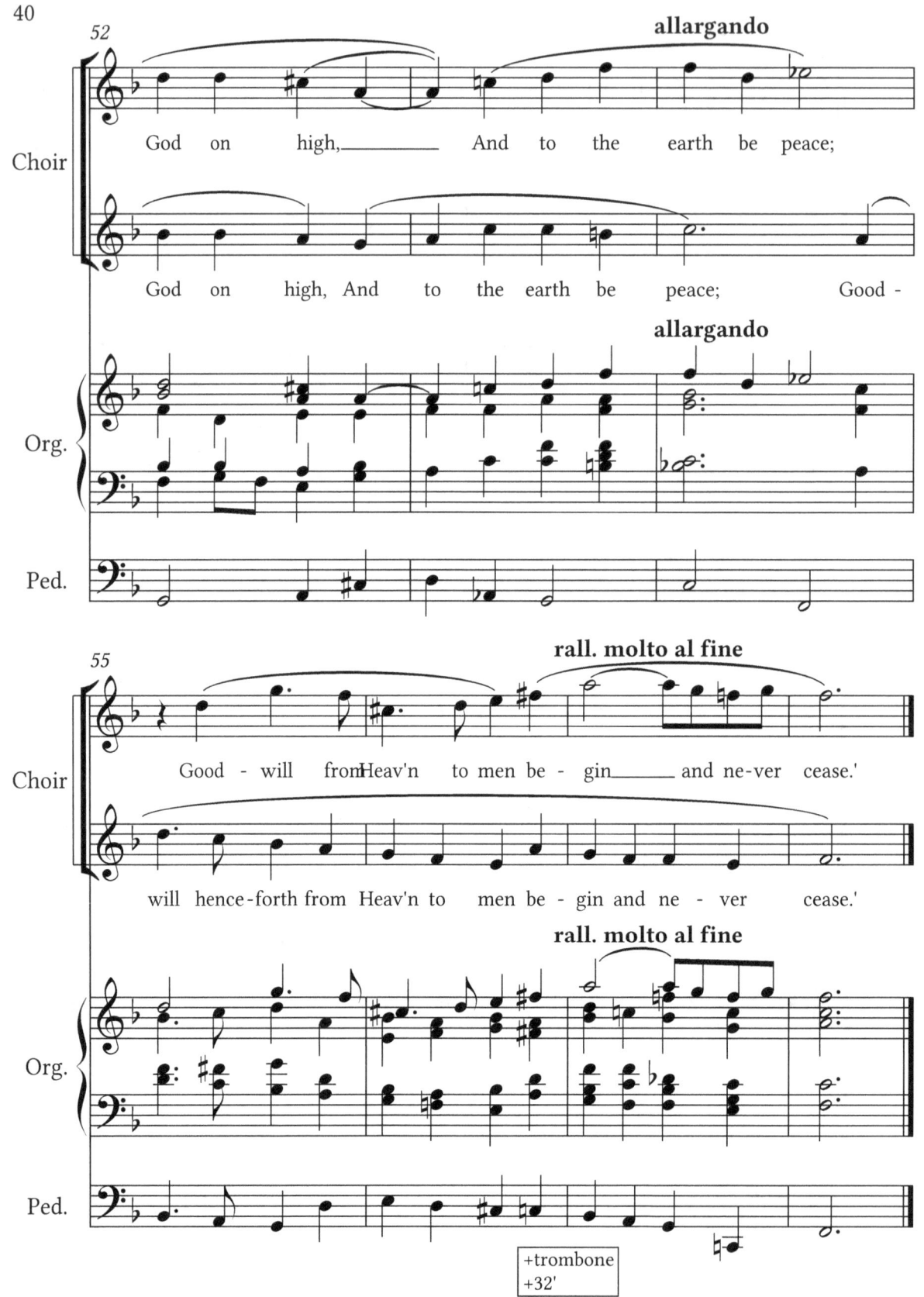

O come, all ye faithful

J.F. Wade (c1711-1786) and E.J.F. Borderies (1764-1832),
tr. Frederick Oakely (1802-1880) and W.T. Brooke (1848-1917)

J.F. Wade (1711-1786)
adapted and arr. Andrew Henderson (b1984)

1. O come, all ye faith-ful, joy-ful and tri-um-phant, O

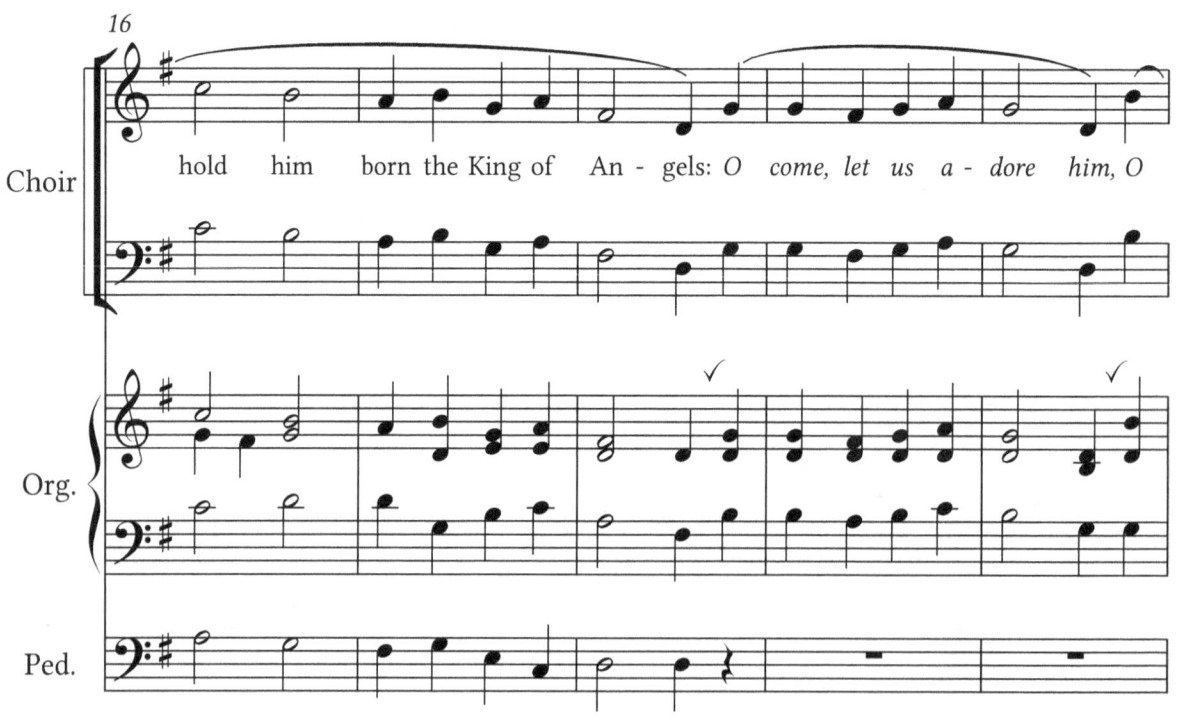

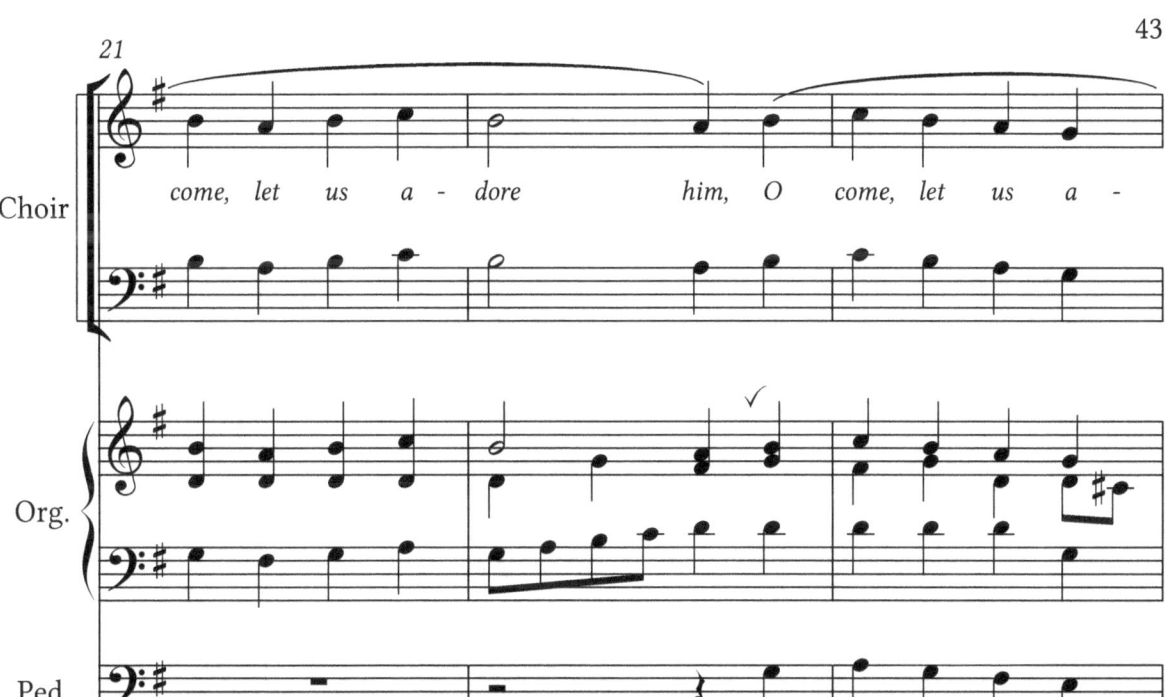
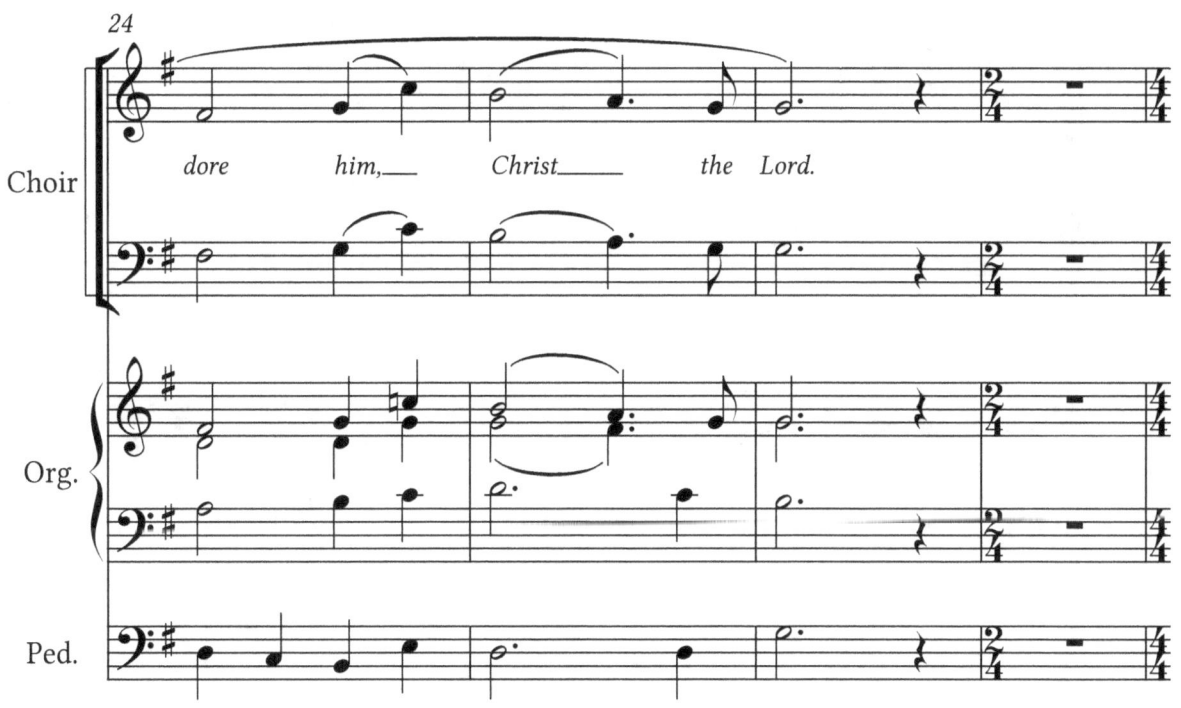

Verse 2

2. God of God, light of light, Lo! he abhors not the Virgin's womb; Very God, be-

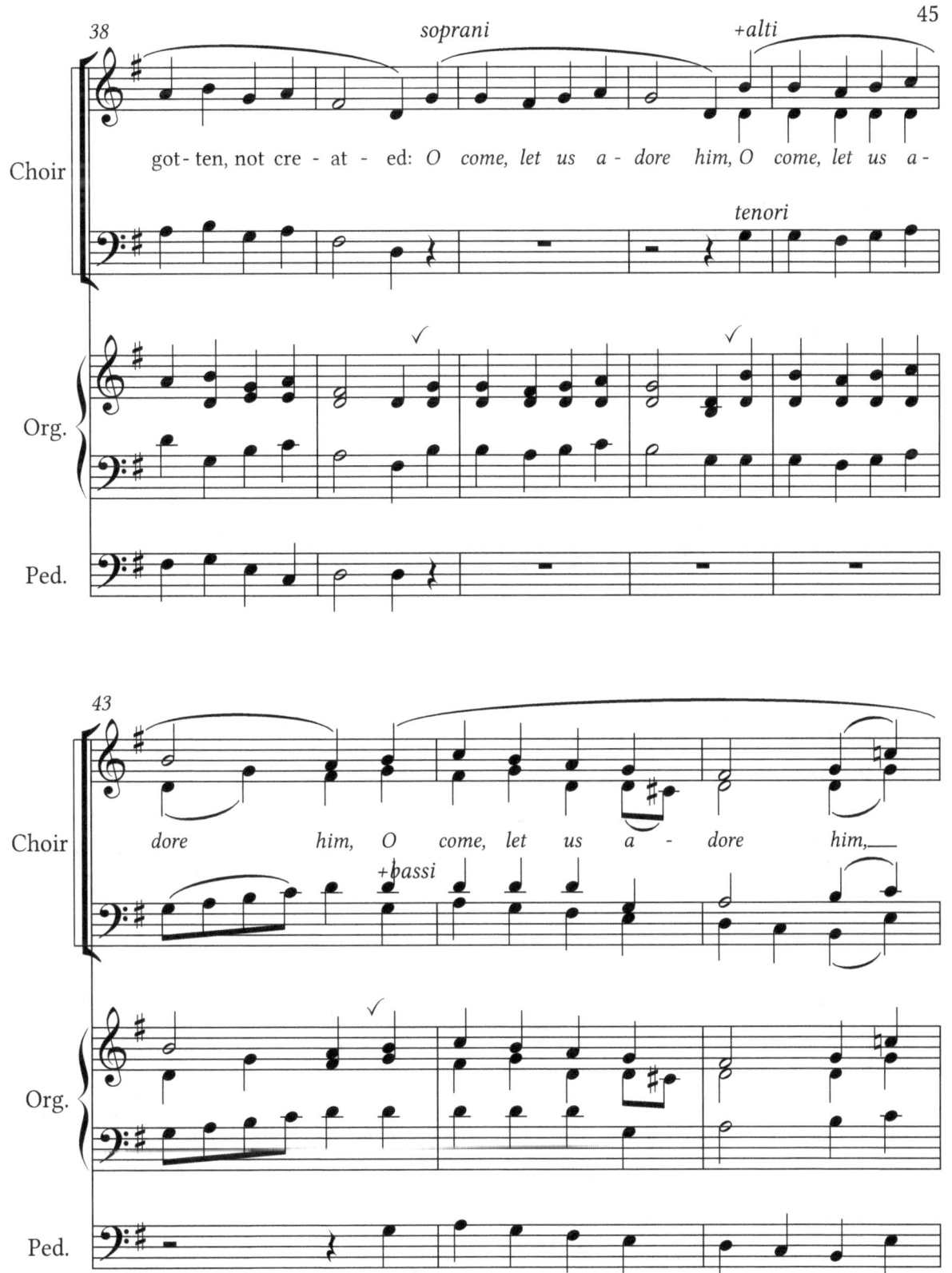

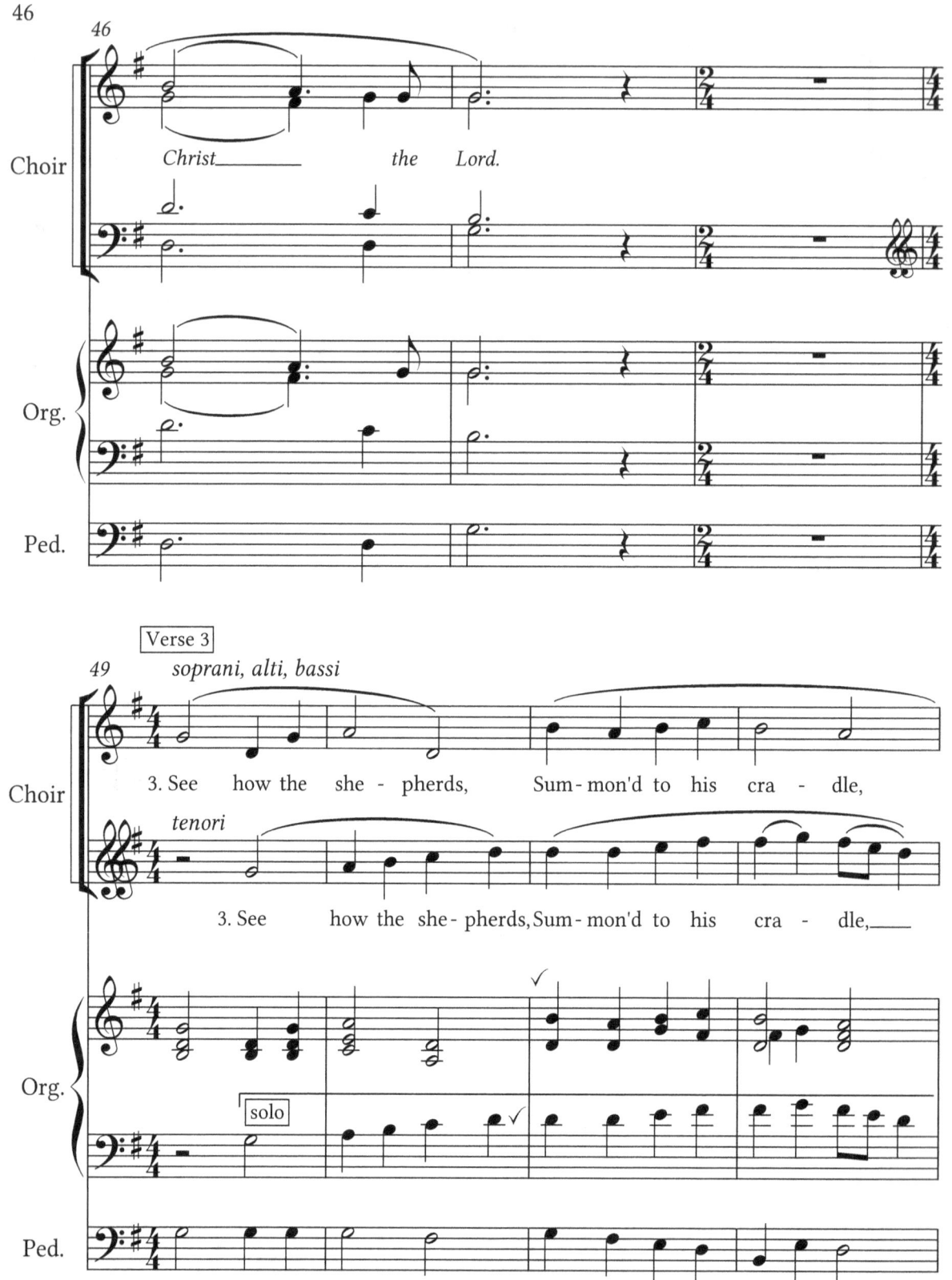

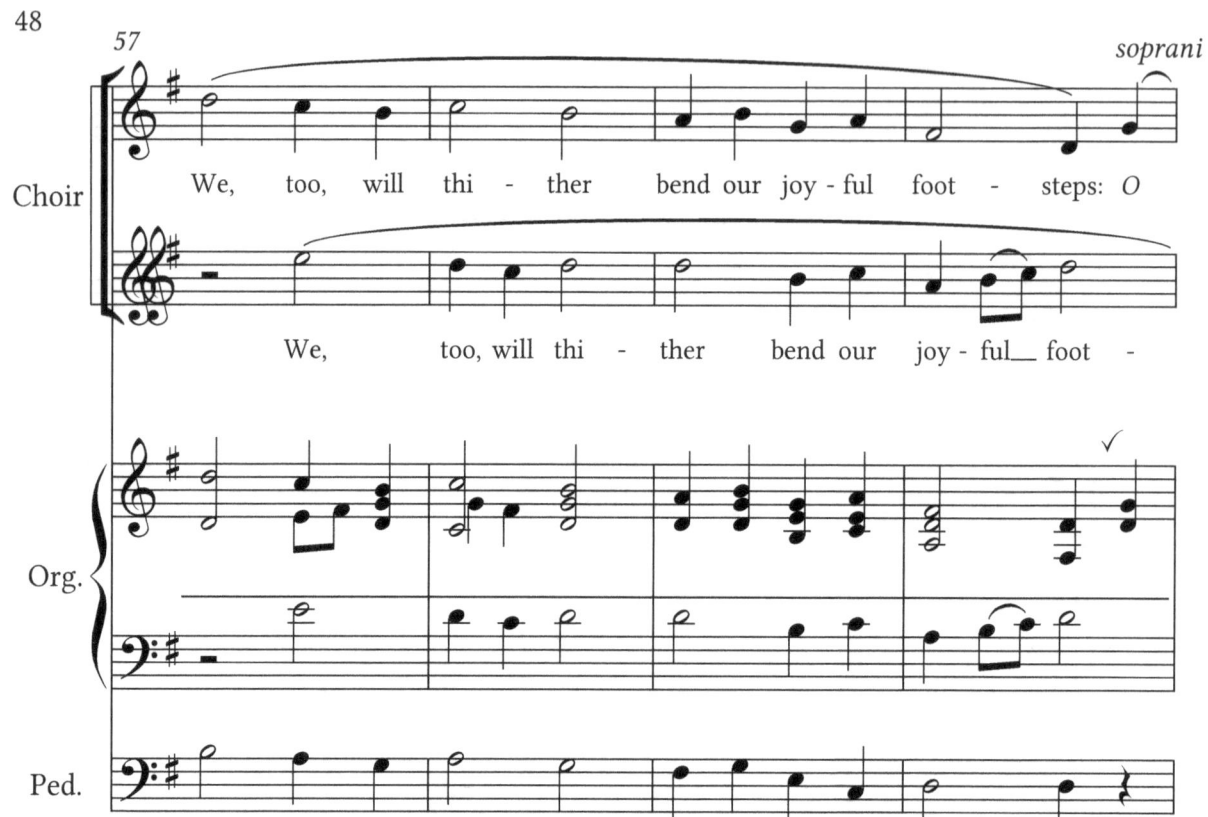

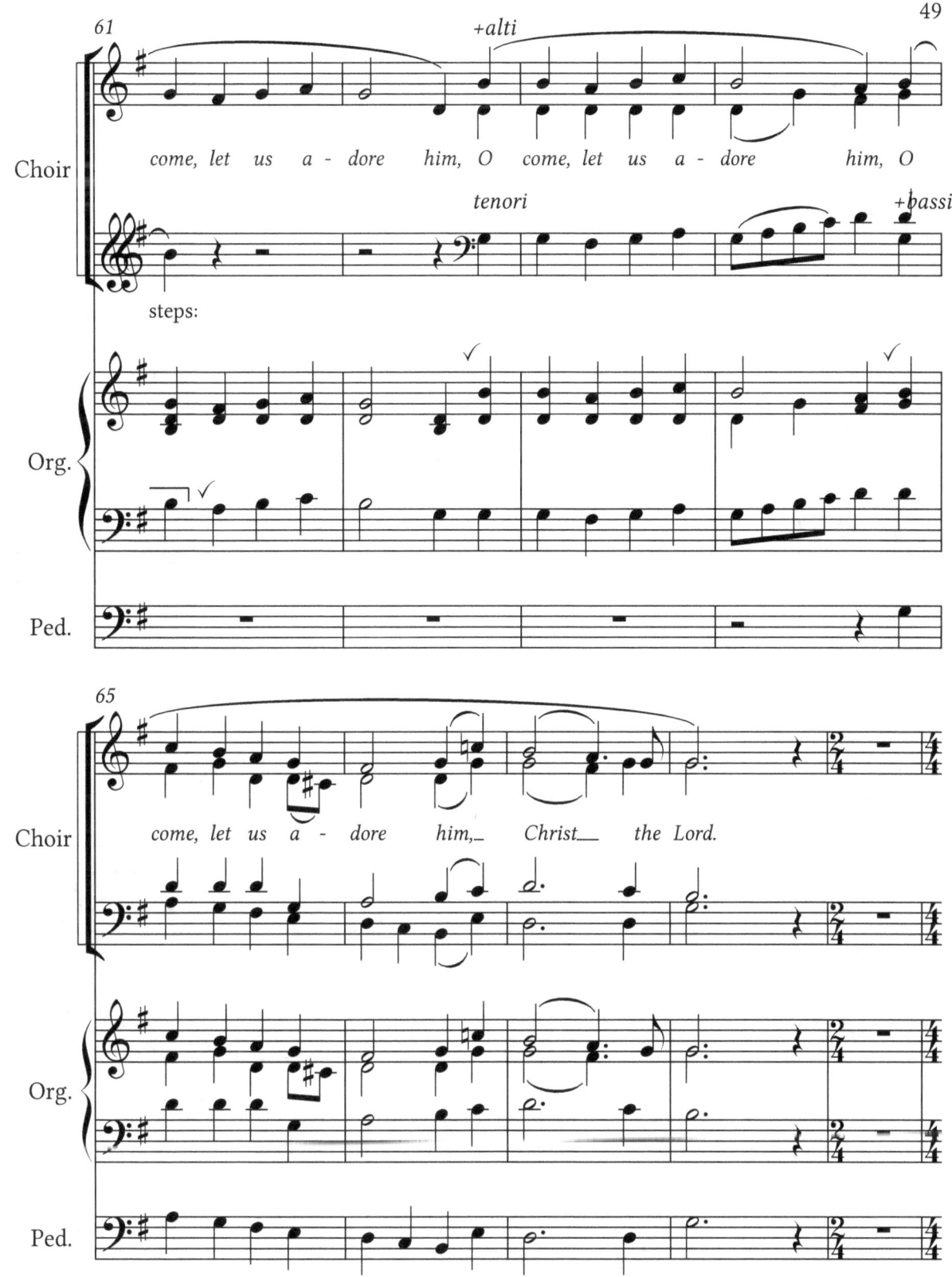

4. Sing, choirs of angels, sing in exultation, Sing, all ye citizens of Heav'n above: 'Glory to God

Hark! the herald-angels sing

Charles Wesley (1707-1788)

Felix Mendelssohn (1809-1847)
adapted by W.H. Cummings (1839-1915)

54

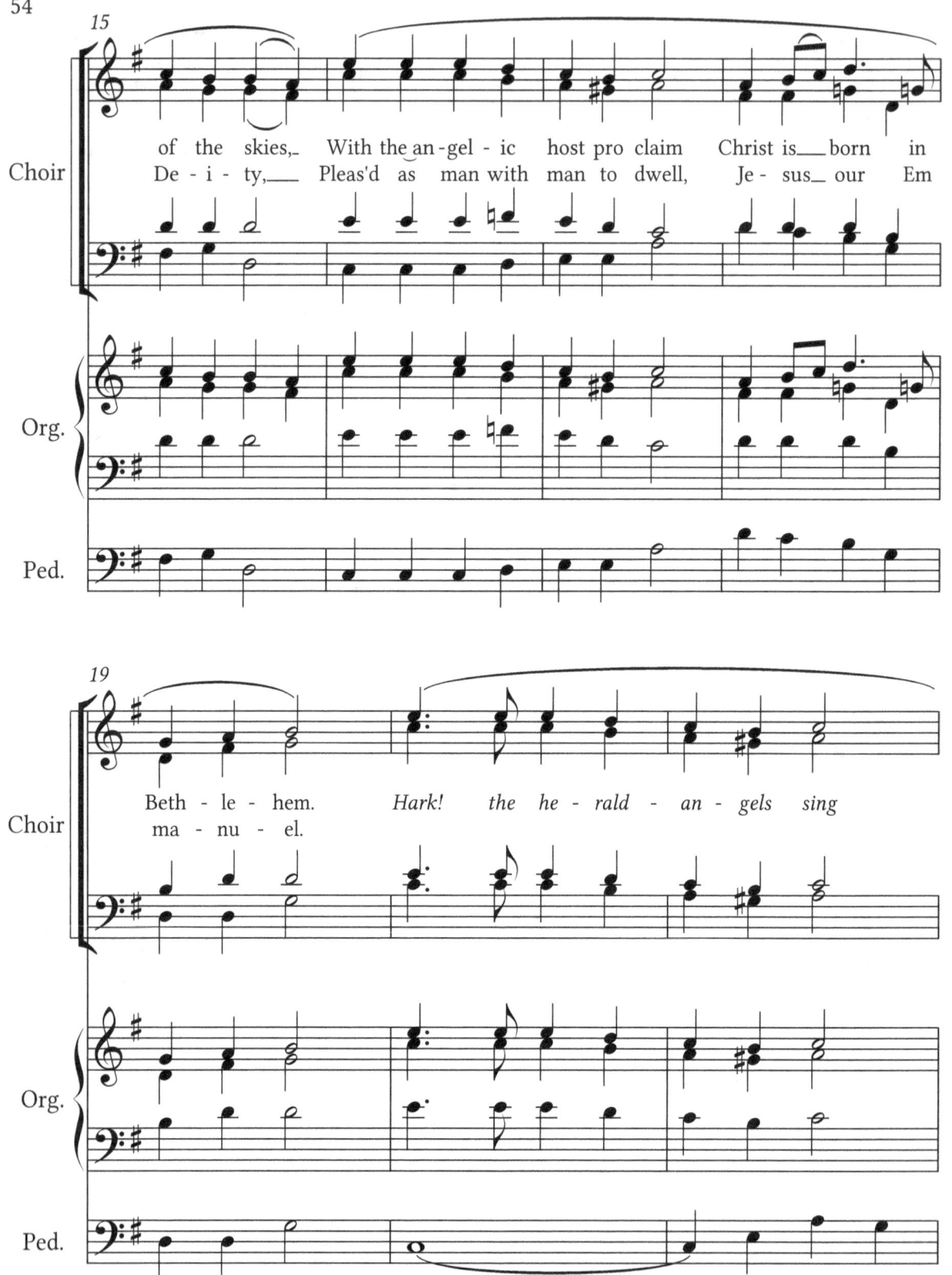

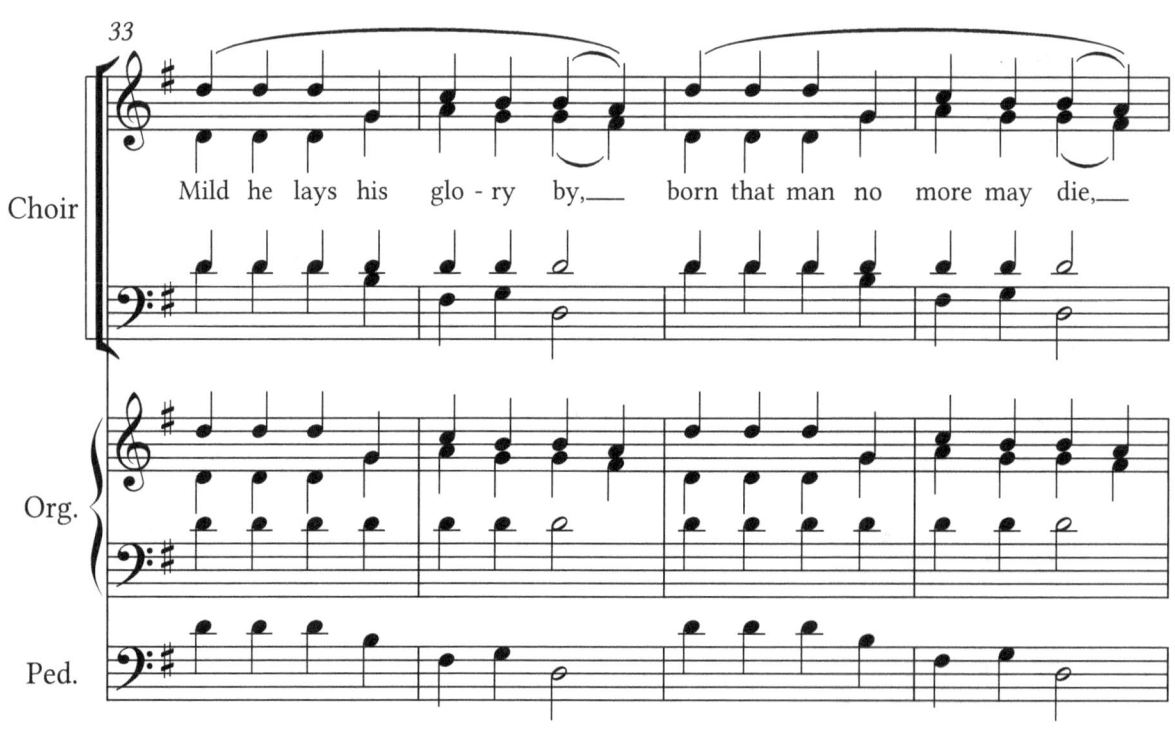

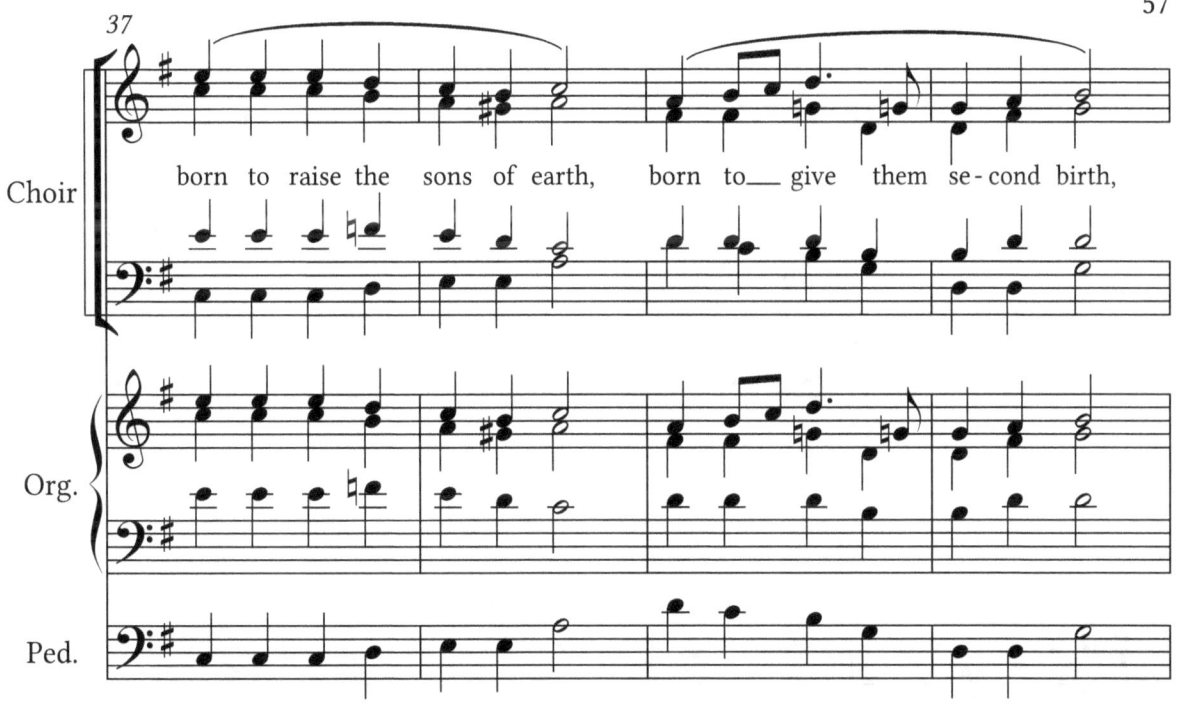

There is no Rose of such virtue

English traditional, c1420
Andrew Henderson (b1984)

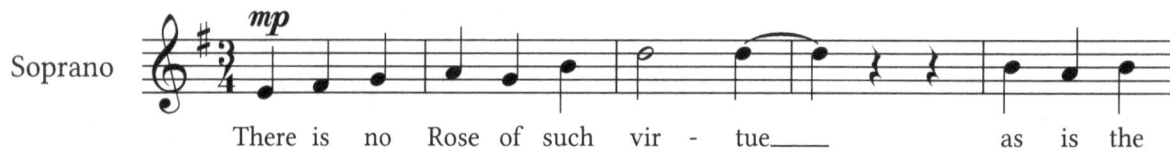

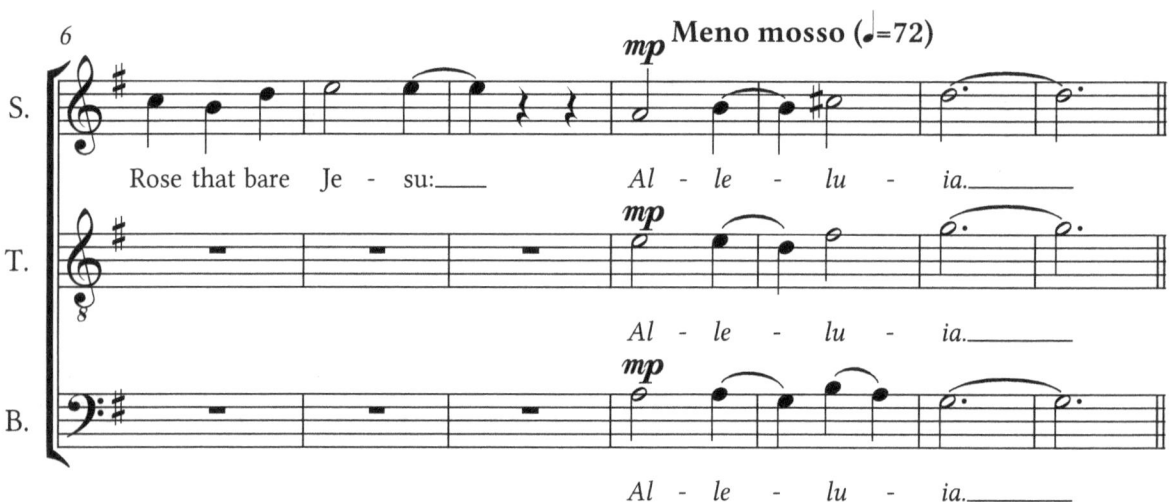

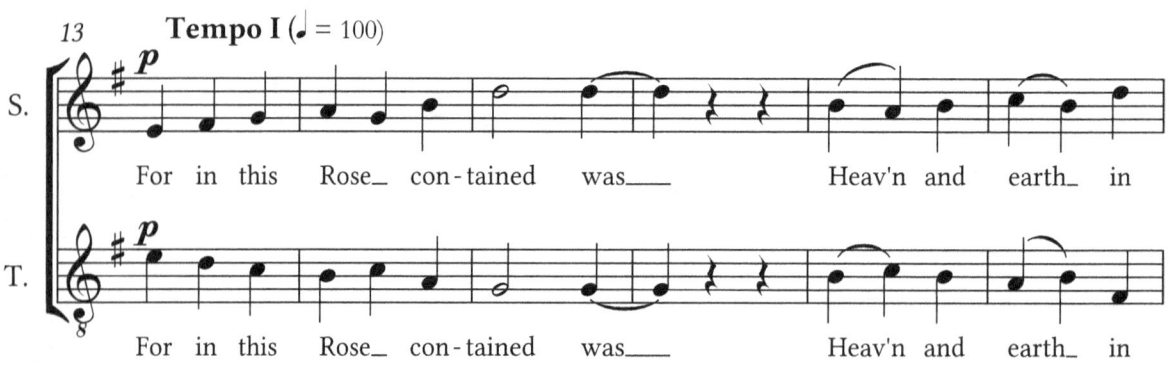

59

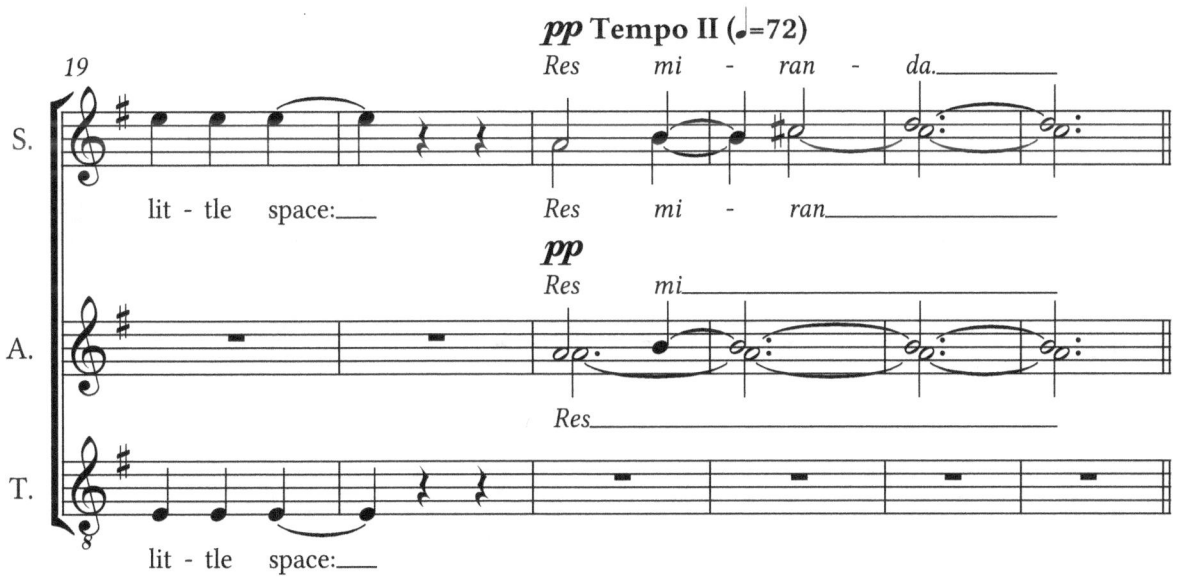
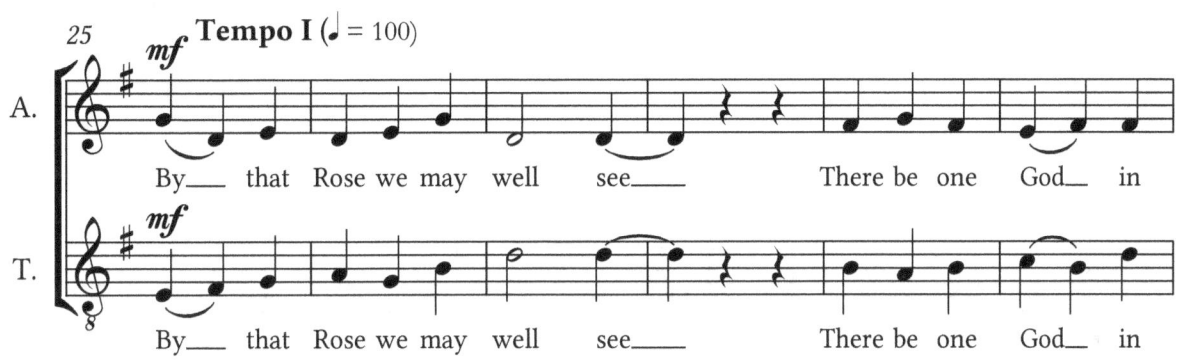
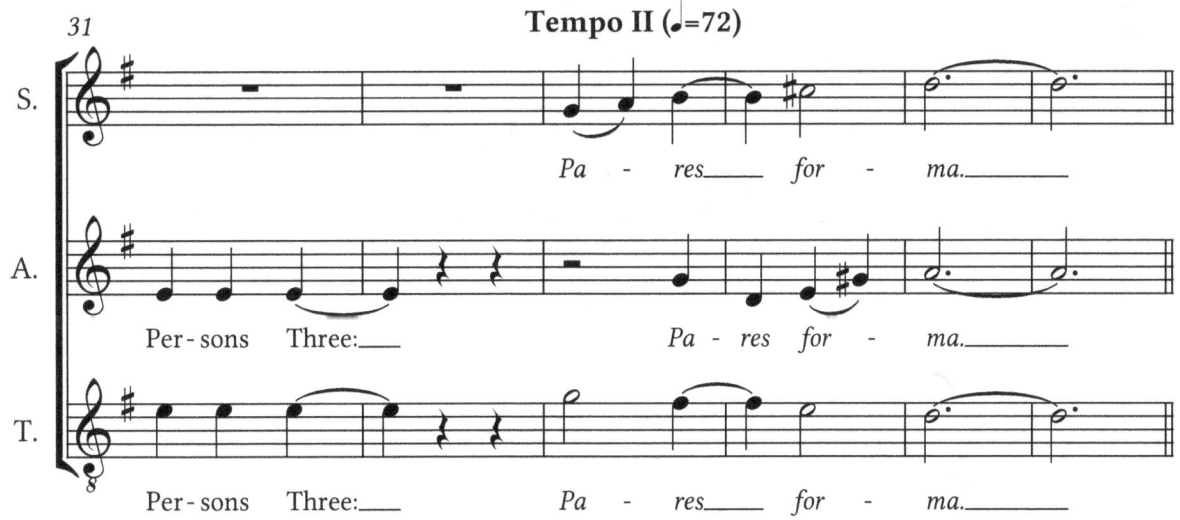

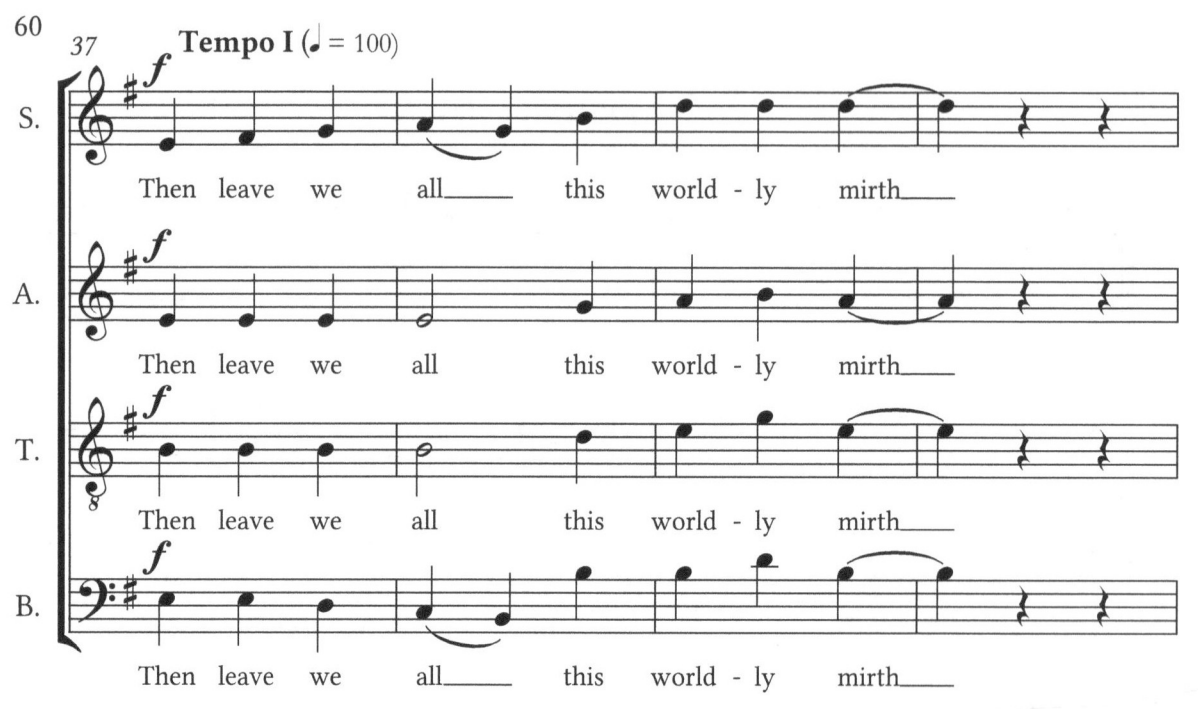

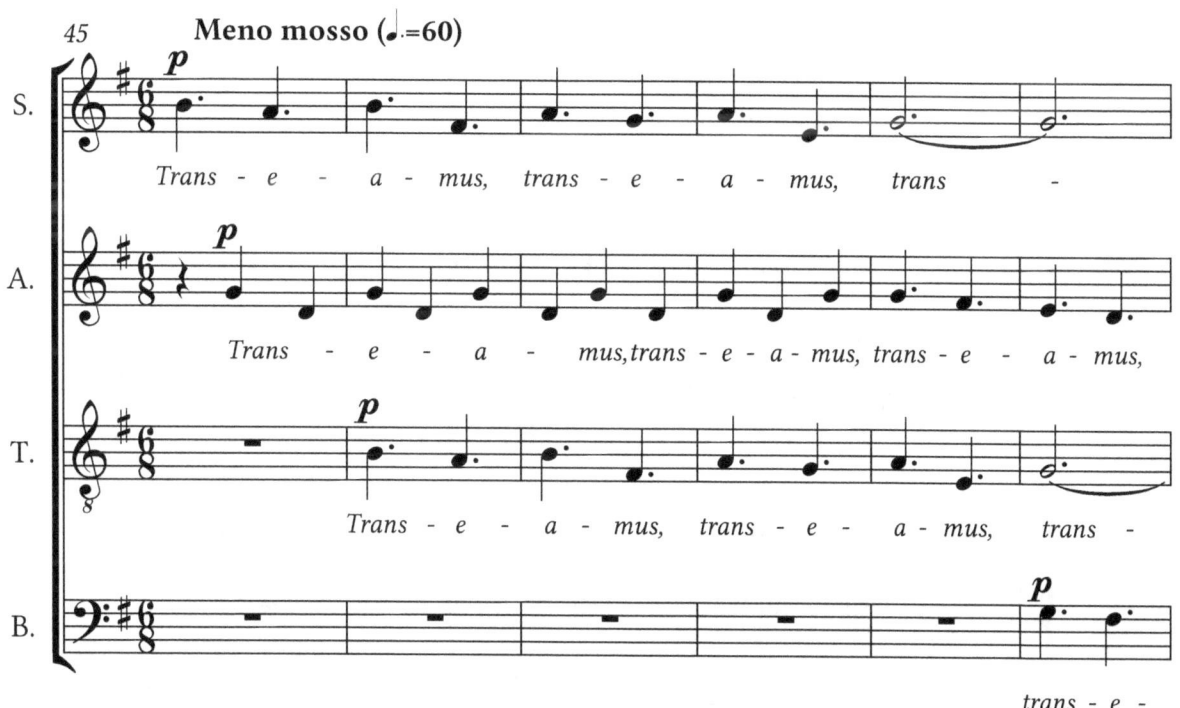
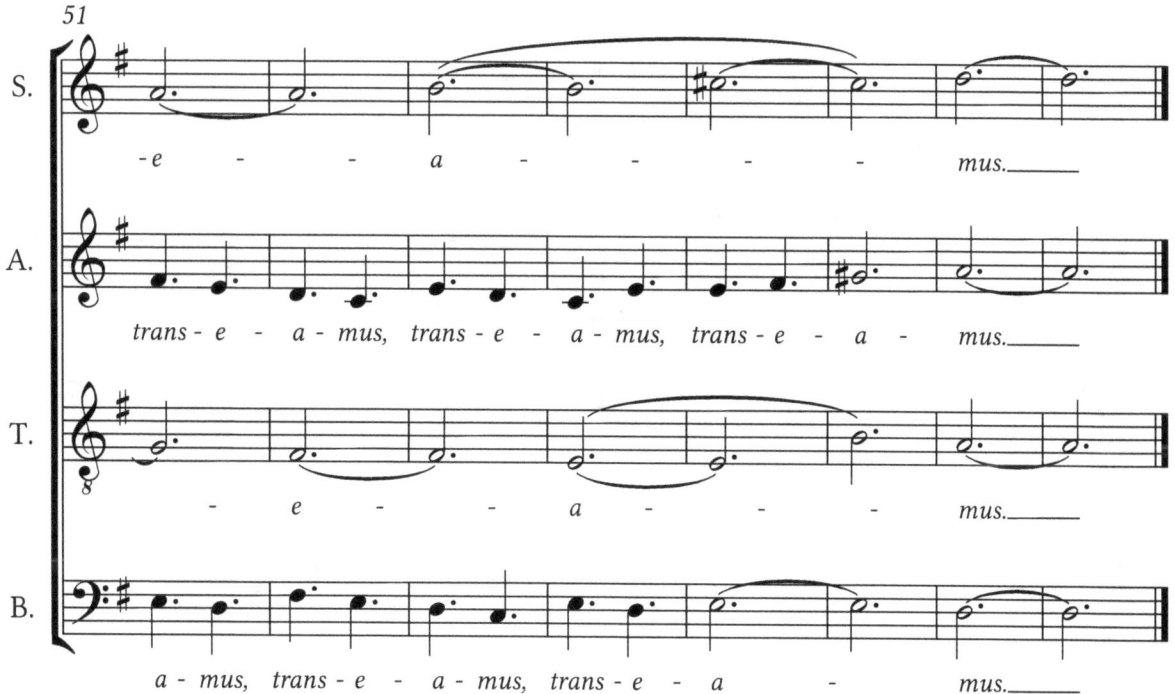

I sing of a Maiden

14th-century Warwickshire carol Andrew Henderson (b1984)

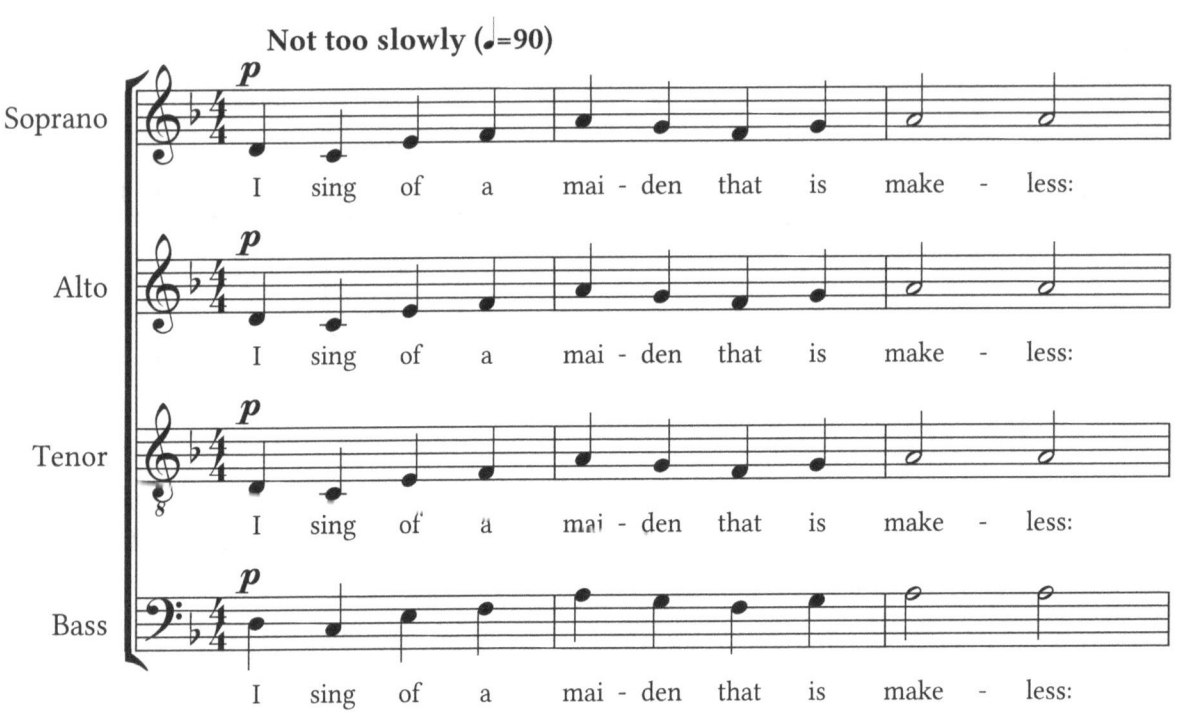

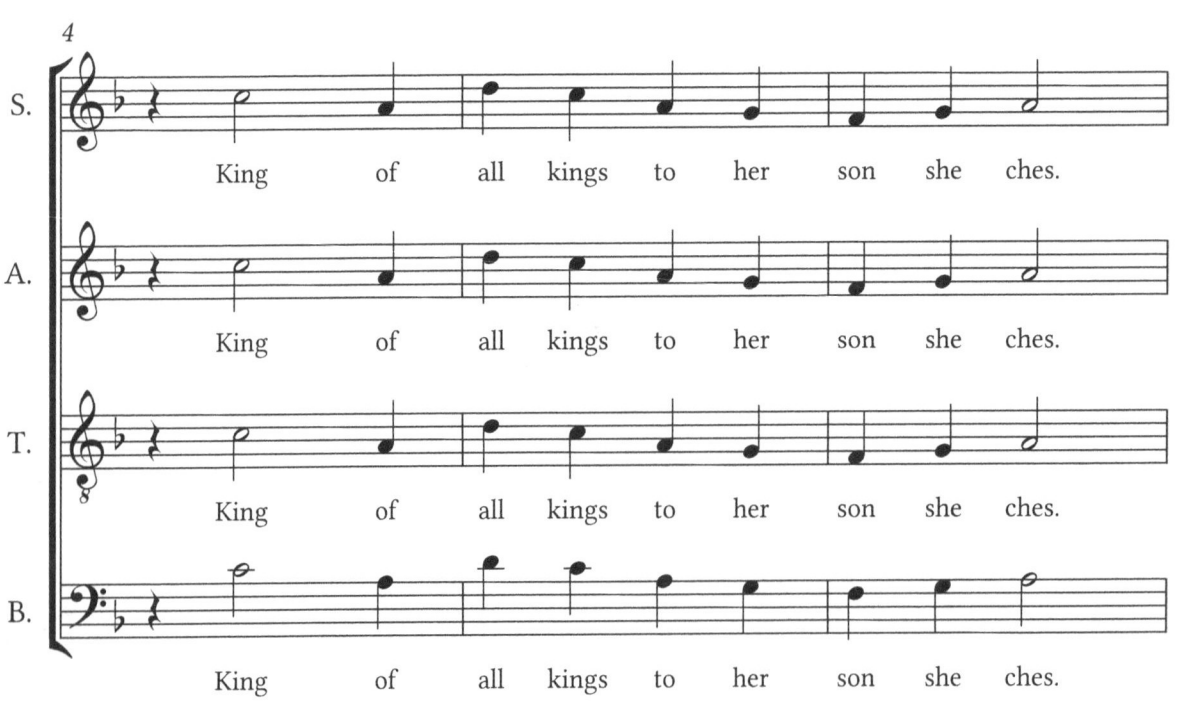

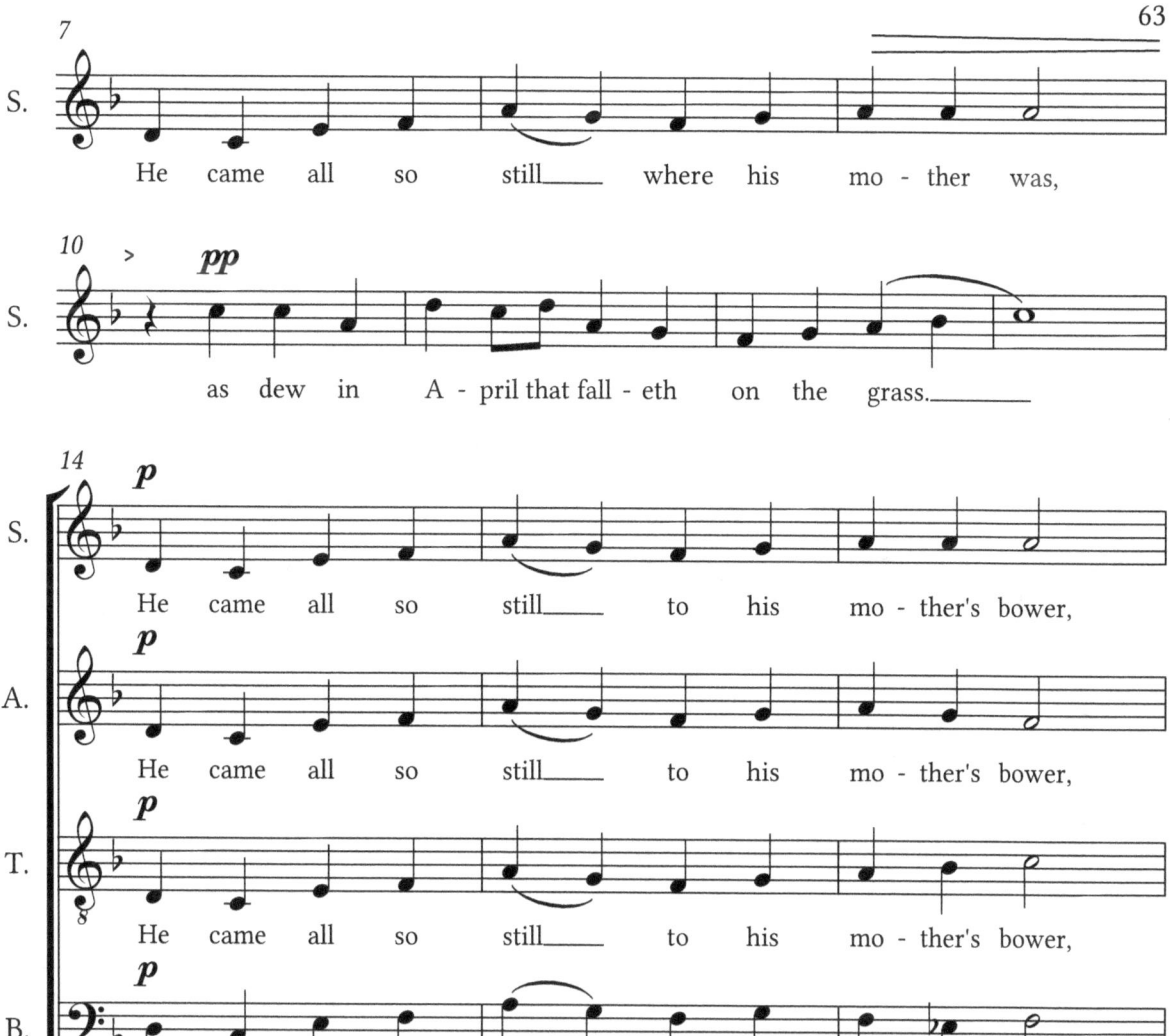

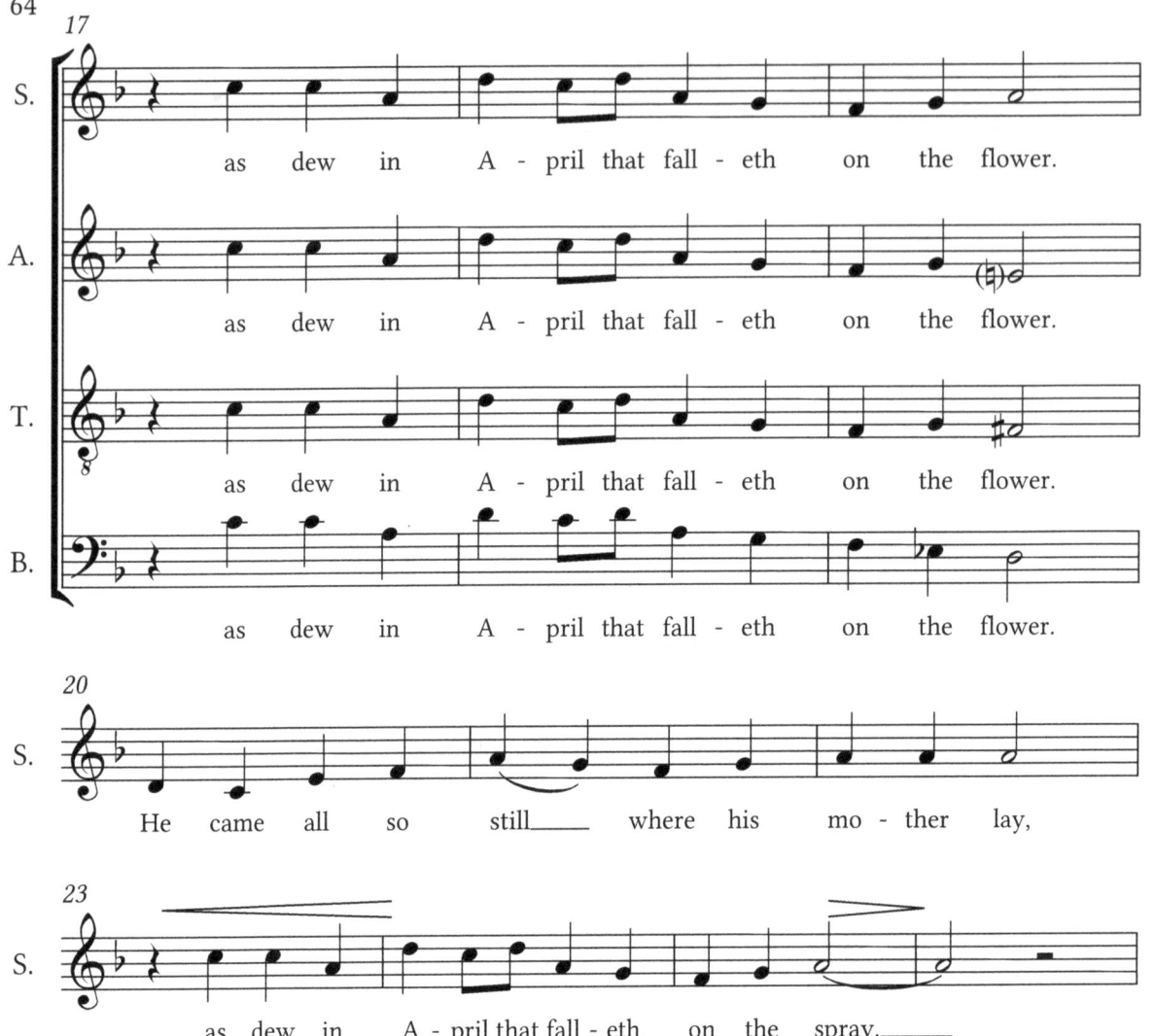

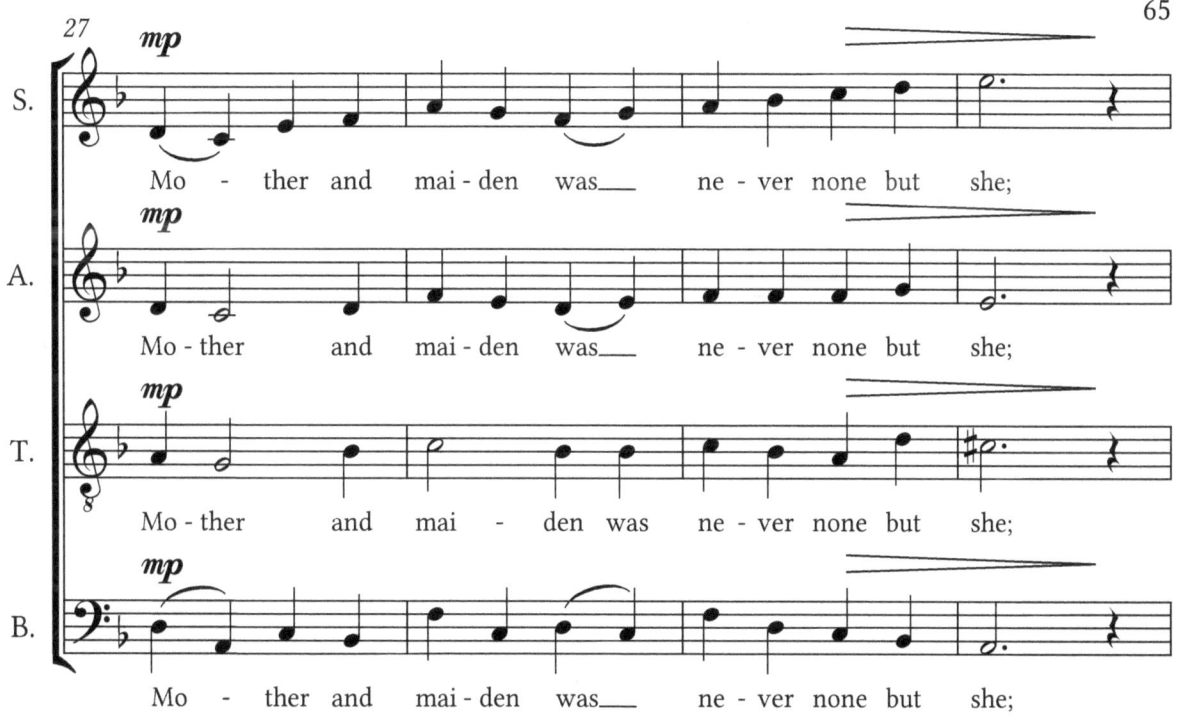

Rejoice Lordings

Medieval English

Andrew Henderson (b1984)

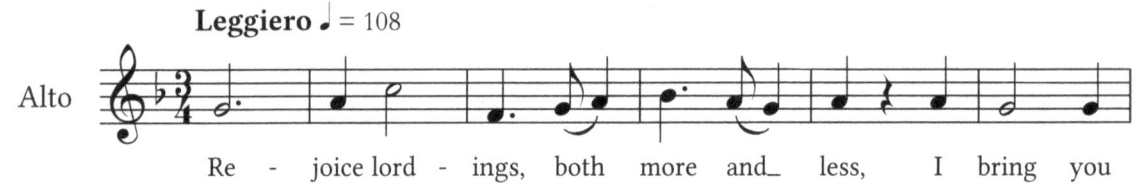
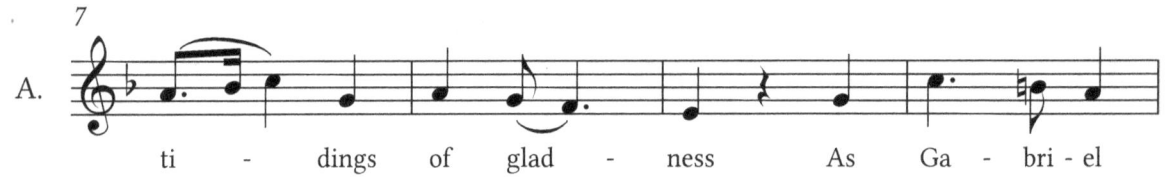
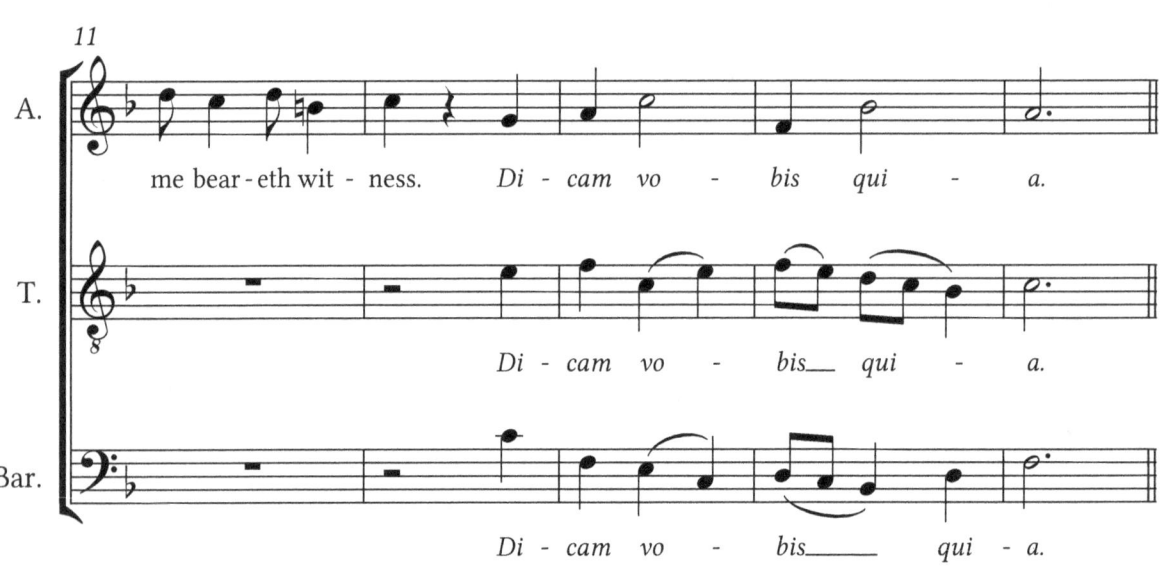
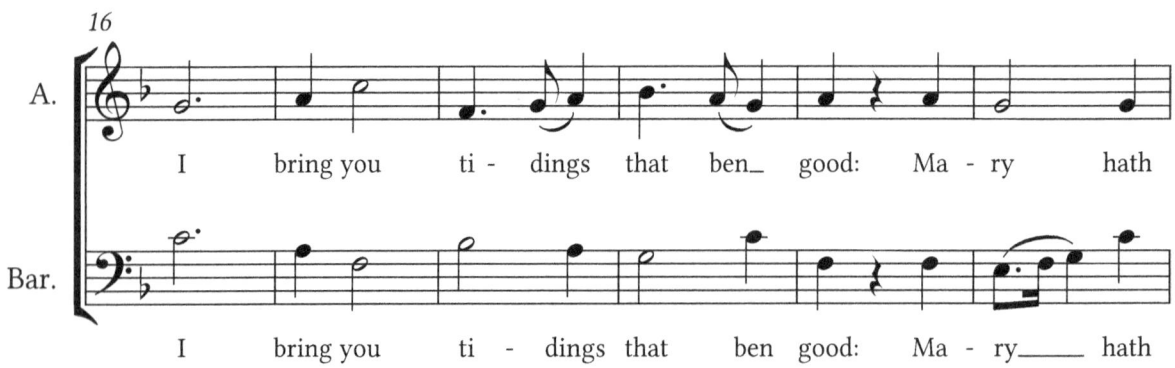

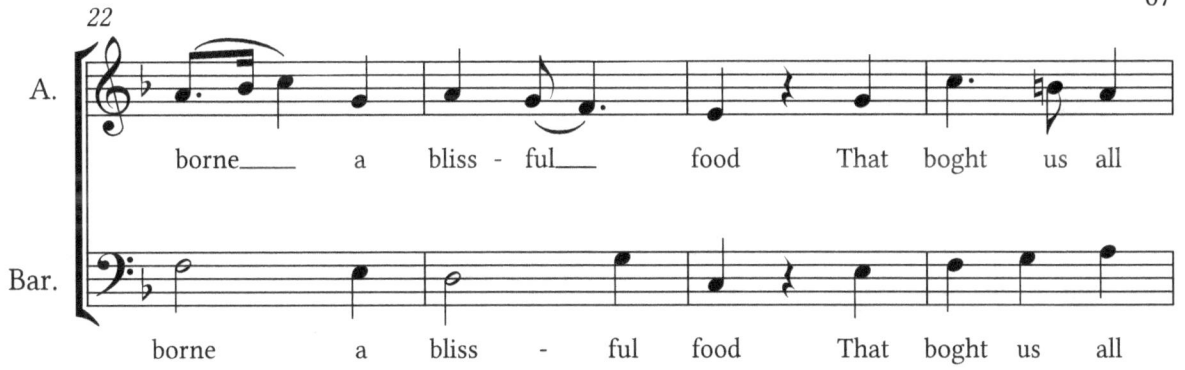
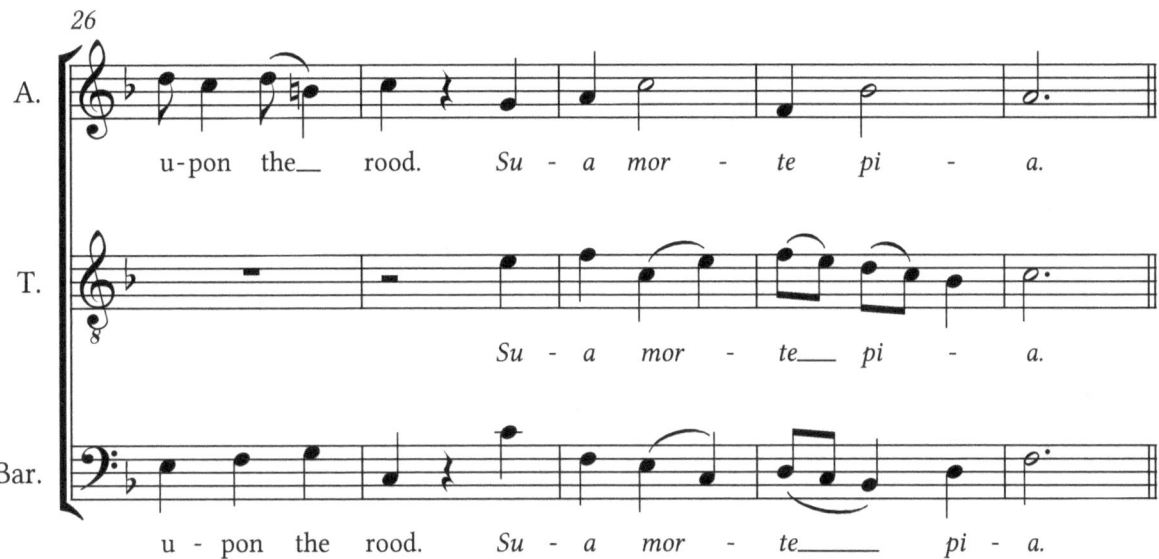
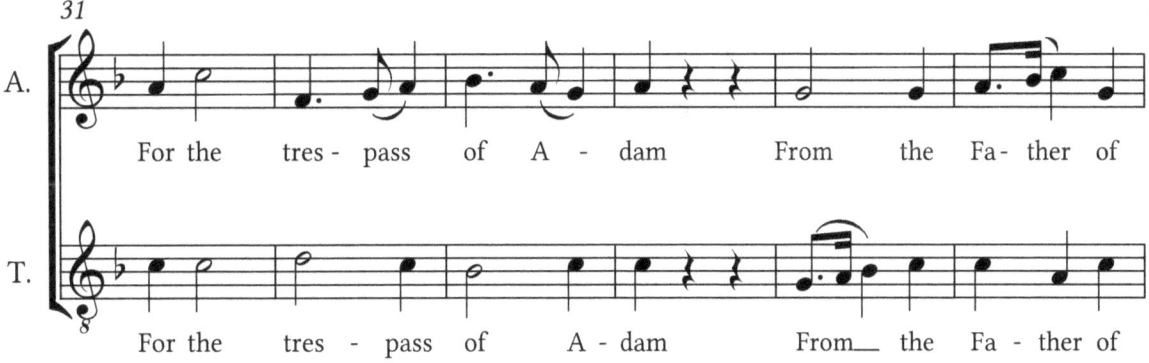

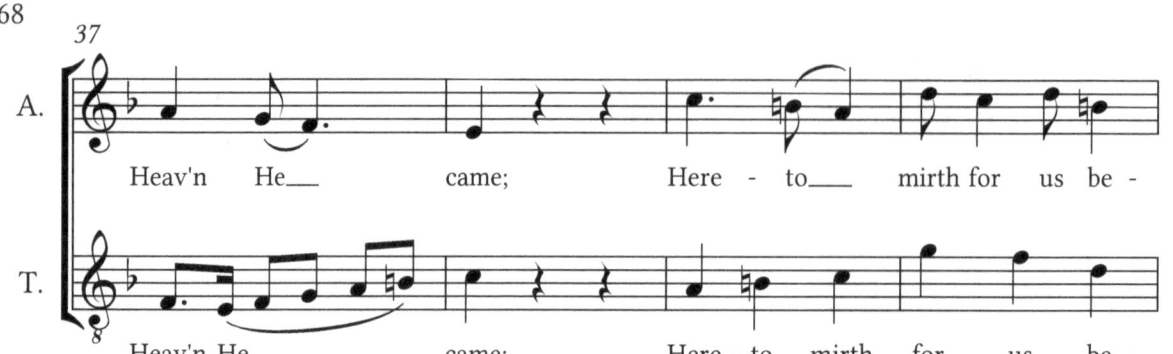
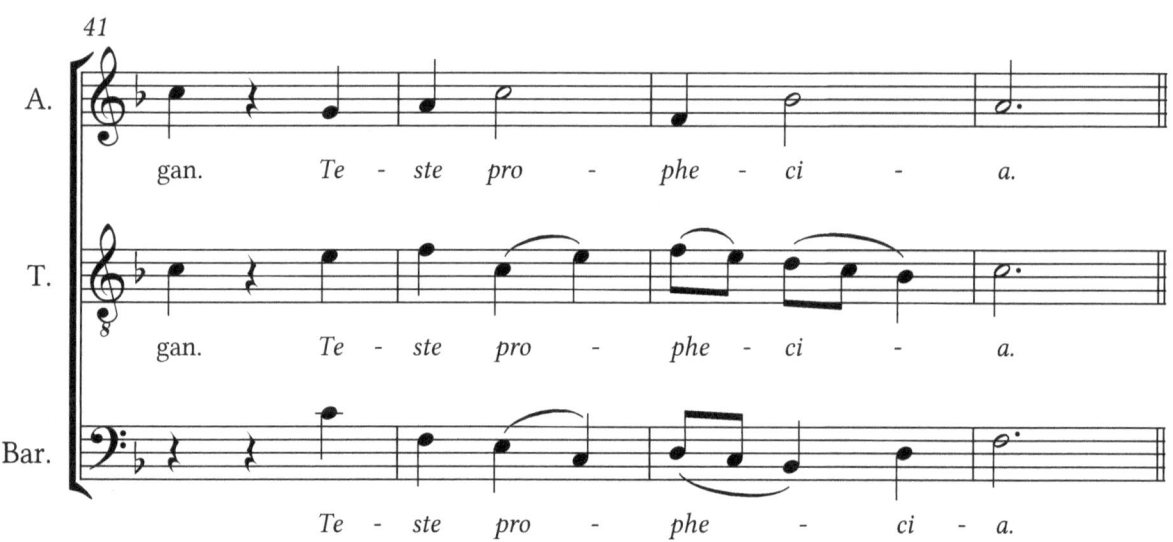
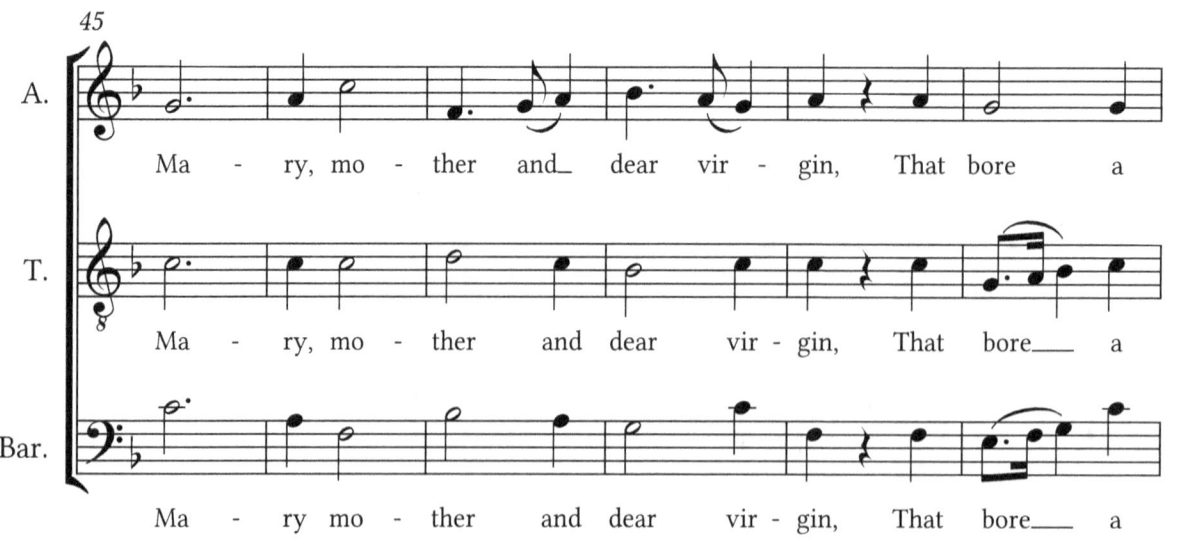

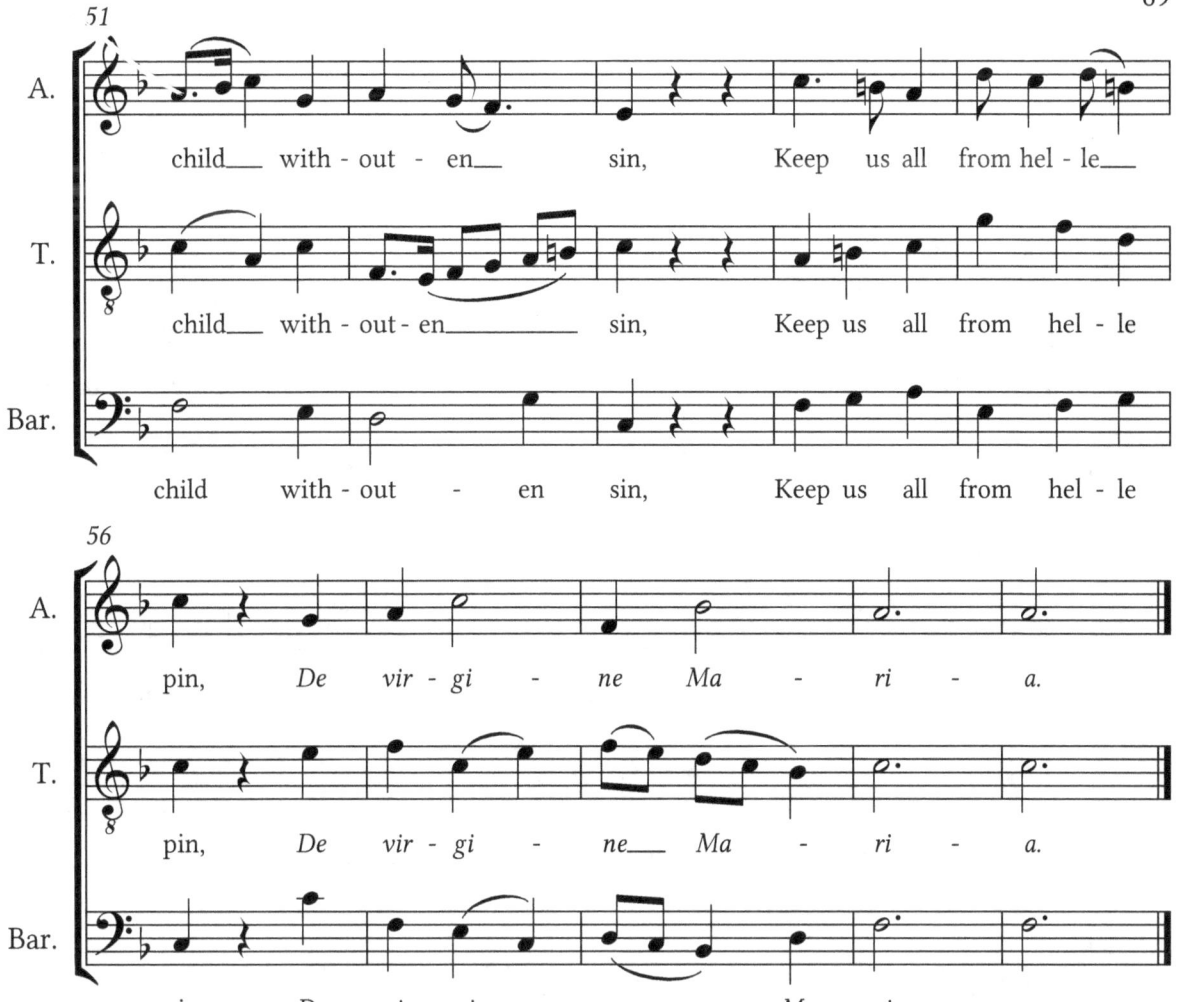

Ding dong! merrily on high

G.R. Woodward (1848-1934) Andrew Henderson (b1984)

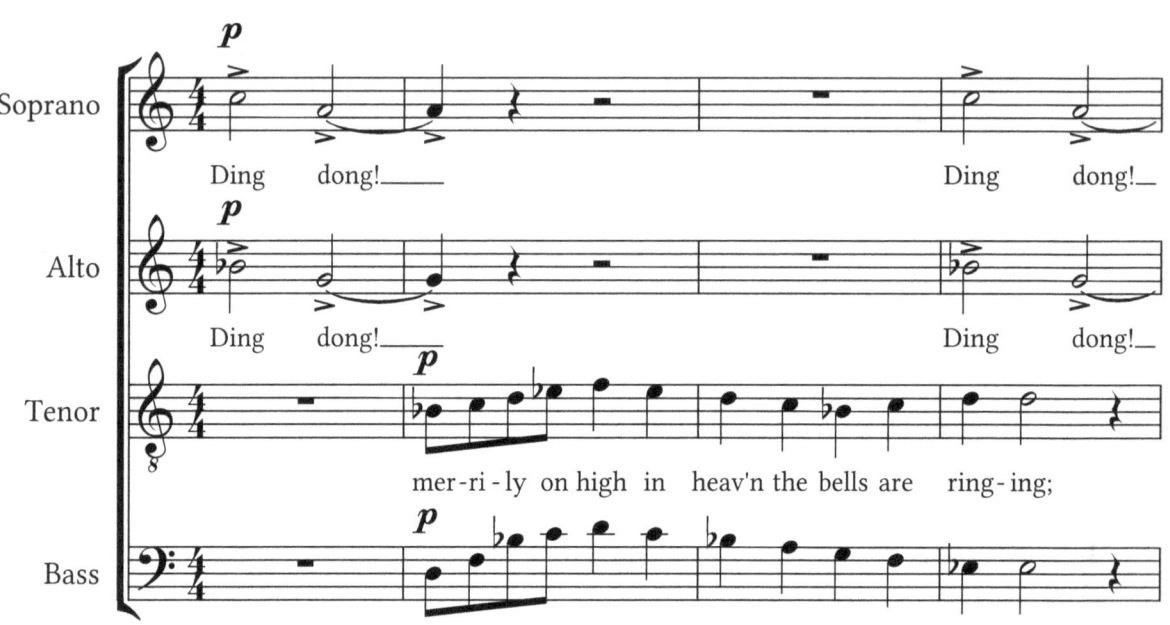

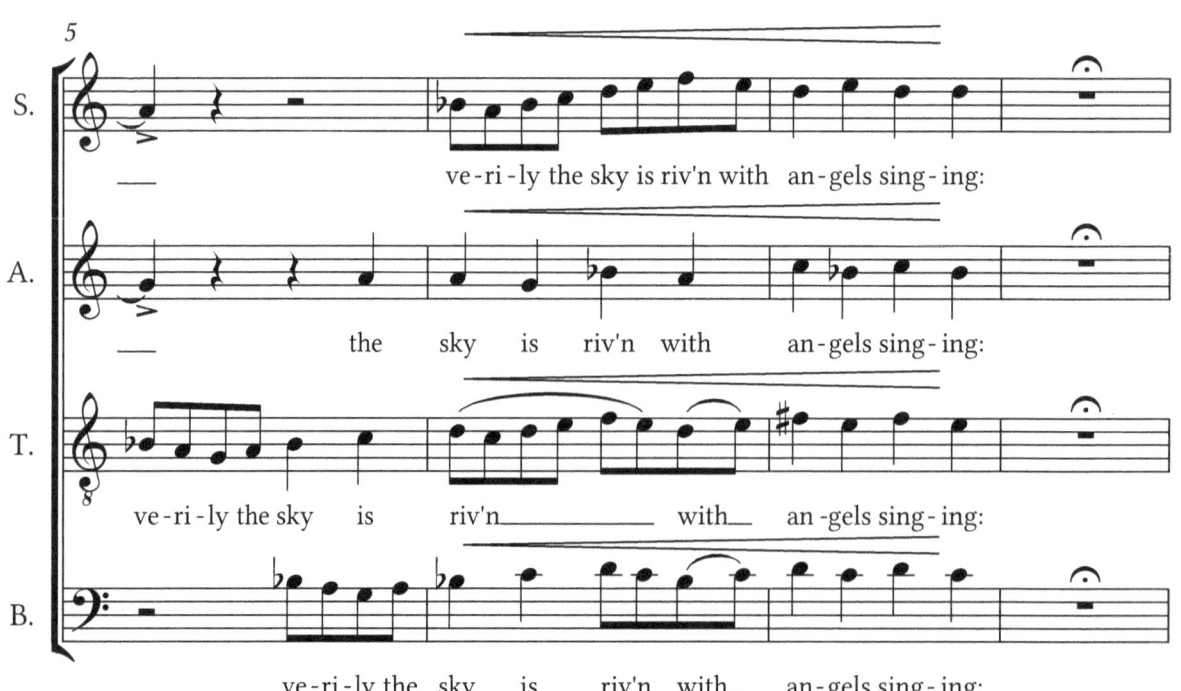

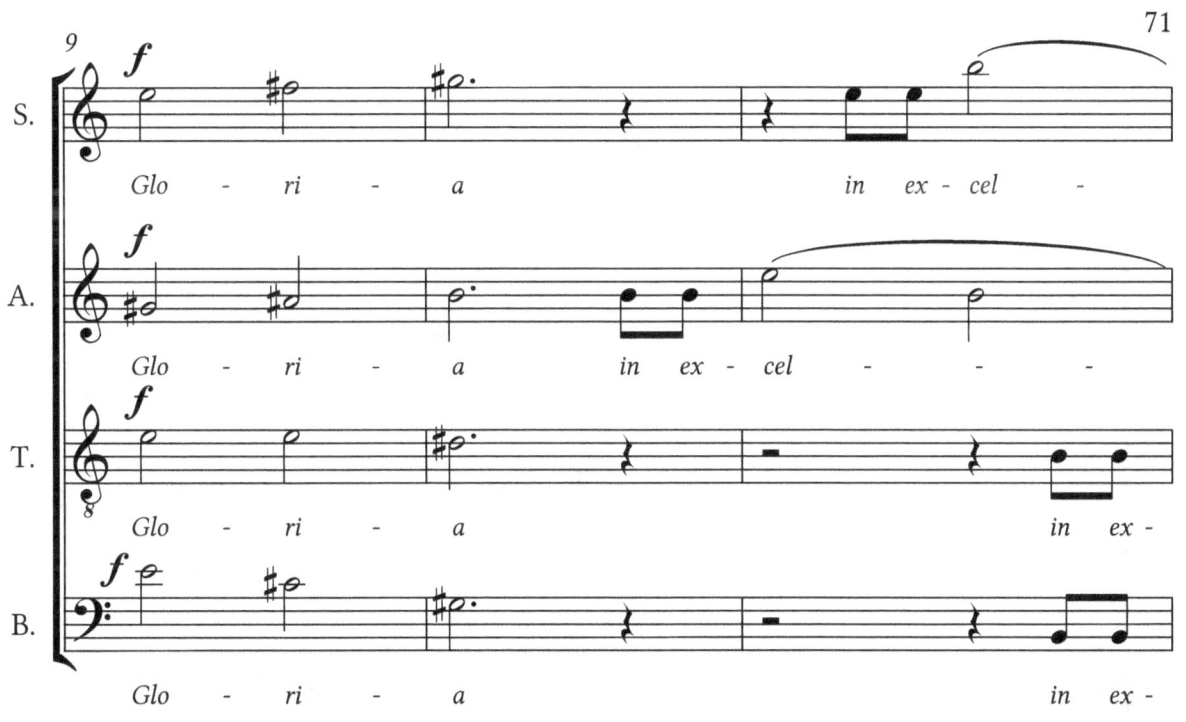
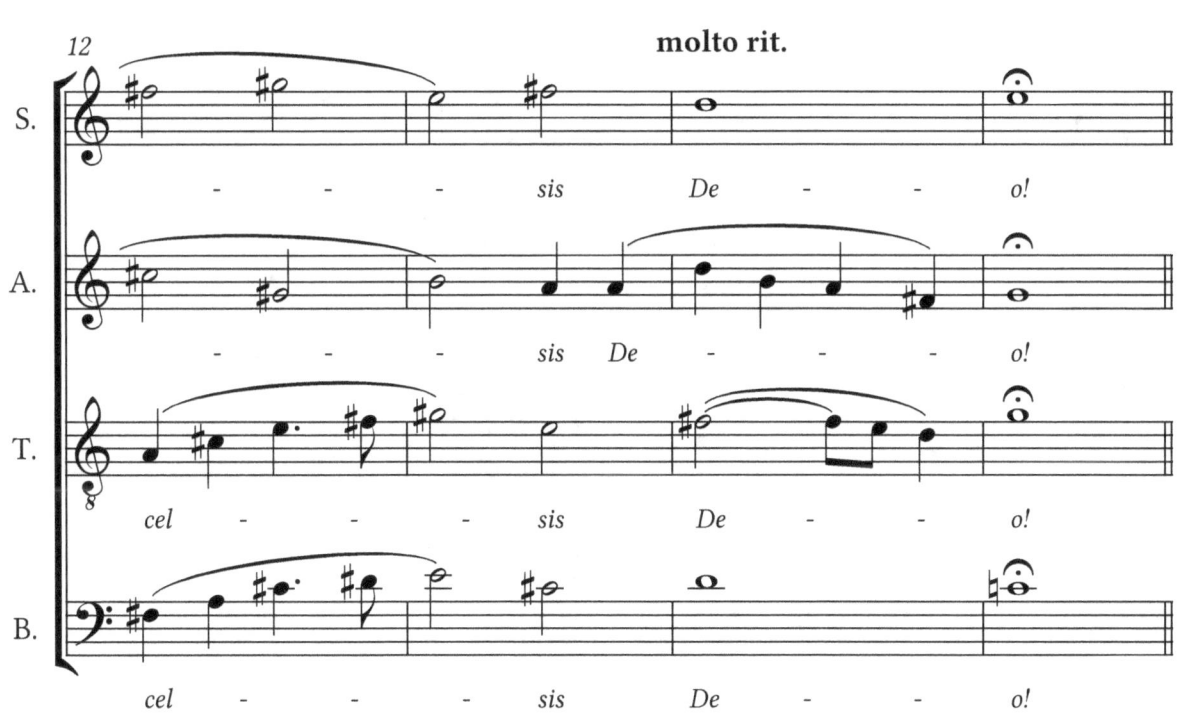

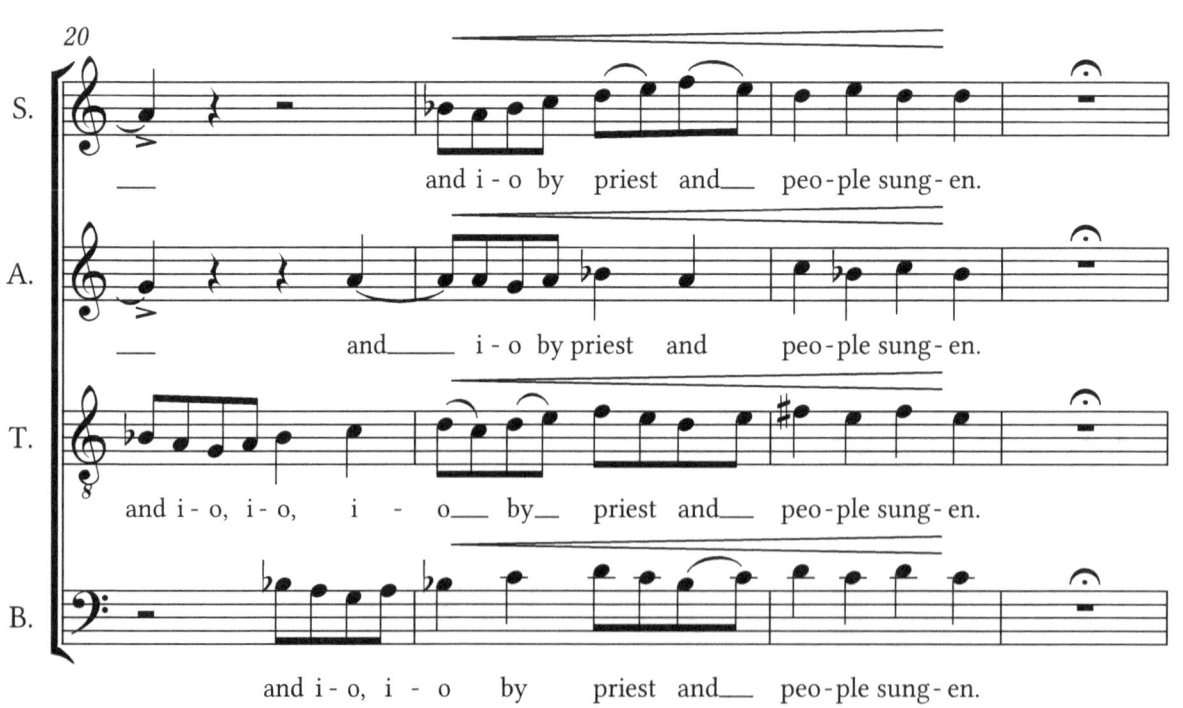

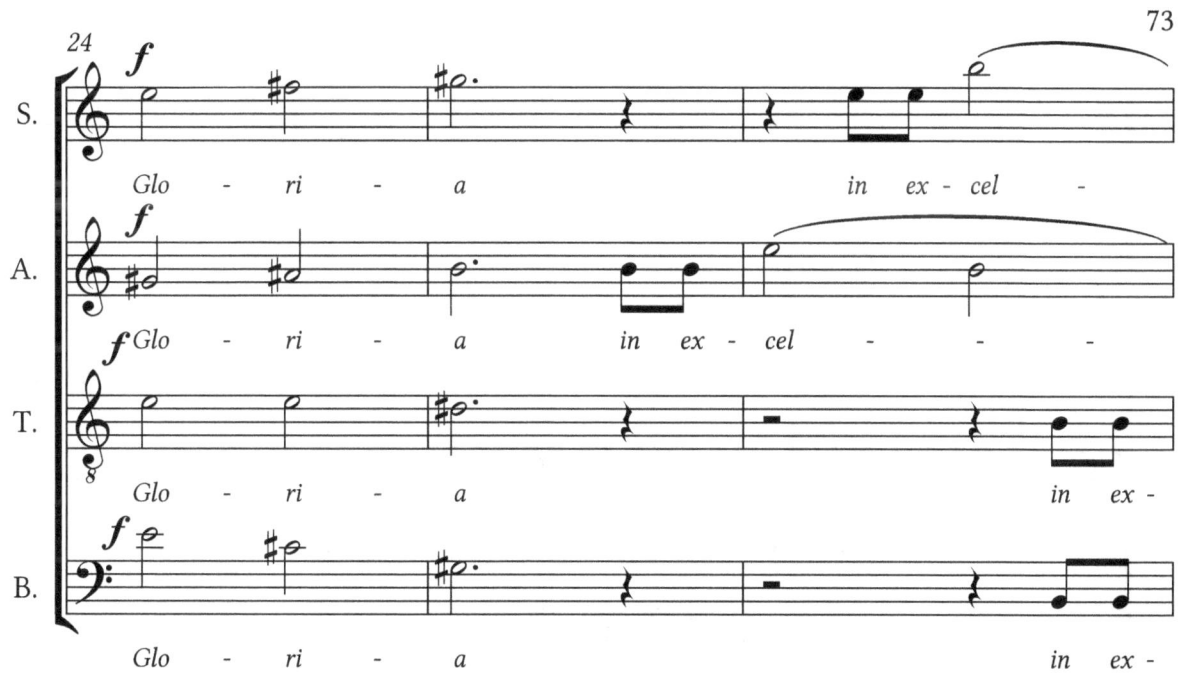

74

tempo primo

S.: Ding dong! ... Ding dong! ...
A.: Ding dong! ... Ding dong! ...
T.: Pray you du-ti-ful-ly prime your mat-tin chime, ye ring-ers;
B.: Pray you du-ti-ful-ly prime your mat-tin chime, ye ring-ers;

S.: may you rime your song, ye sing-ers.
A.: may you rime your eve-time song, ye sing-ers.
T.: may you beau-ti-fu-ly rime your eve-time song, ye sing-ers.
B.: may you beau-ti-ful-ly rime your song, ye sing-ers.

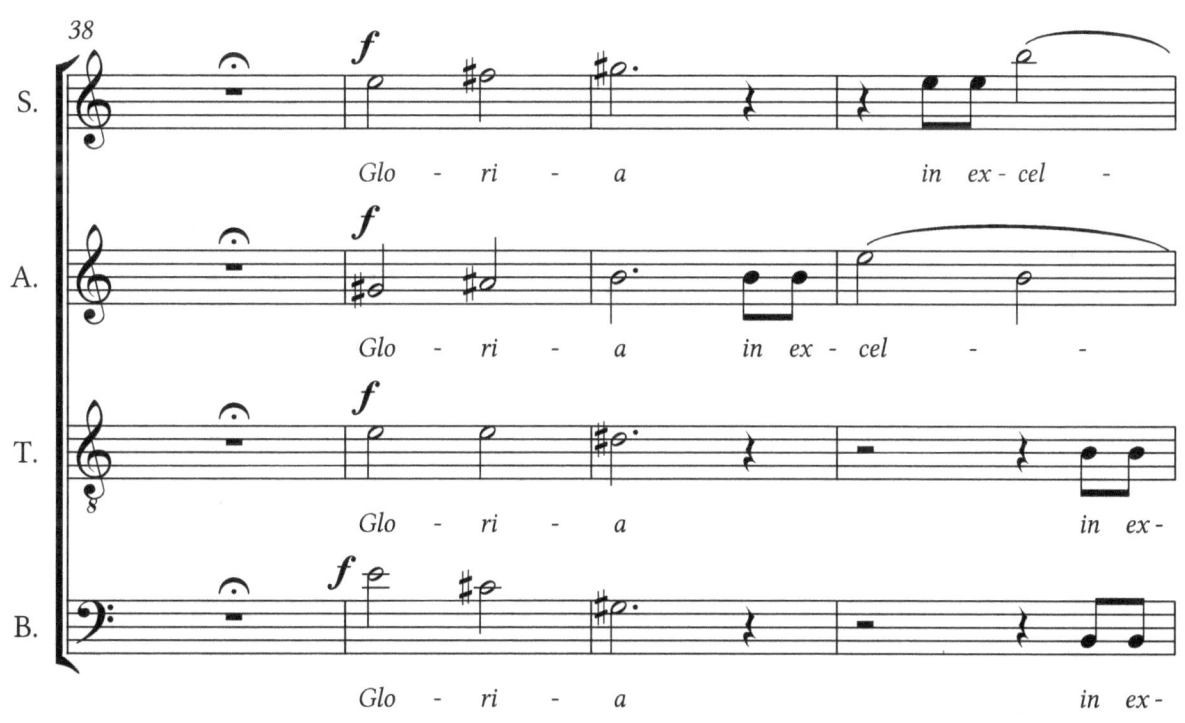

for Peter Jones
The Cherry Tree Carol
A Dialogue

15th century English Andrew Henderson (b1984)

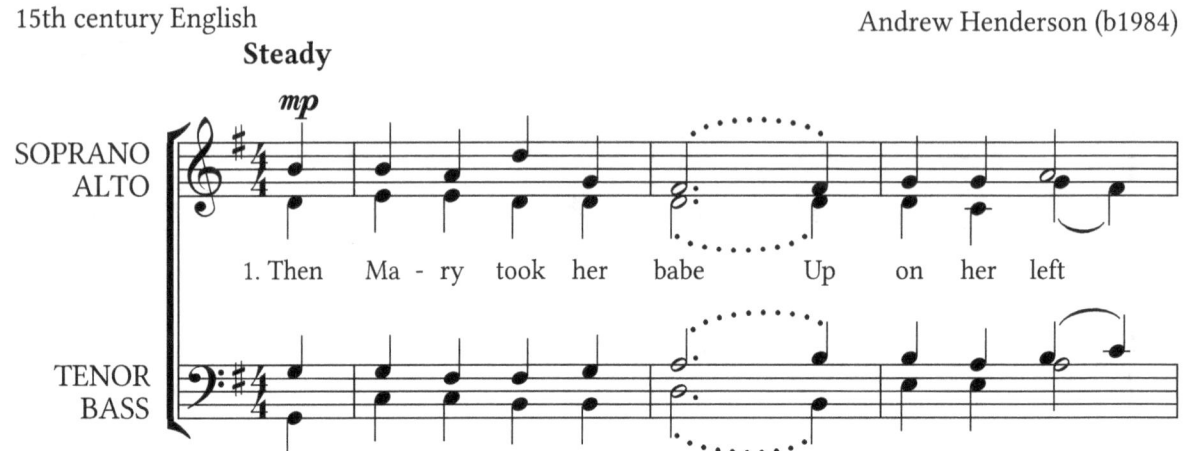

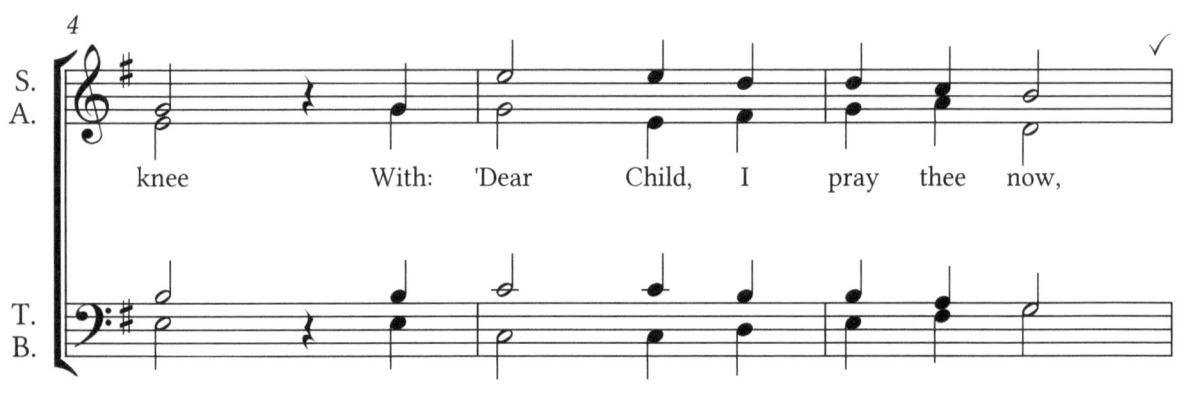

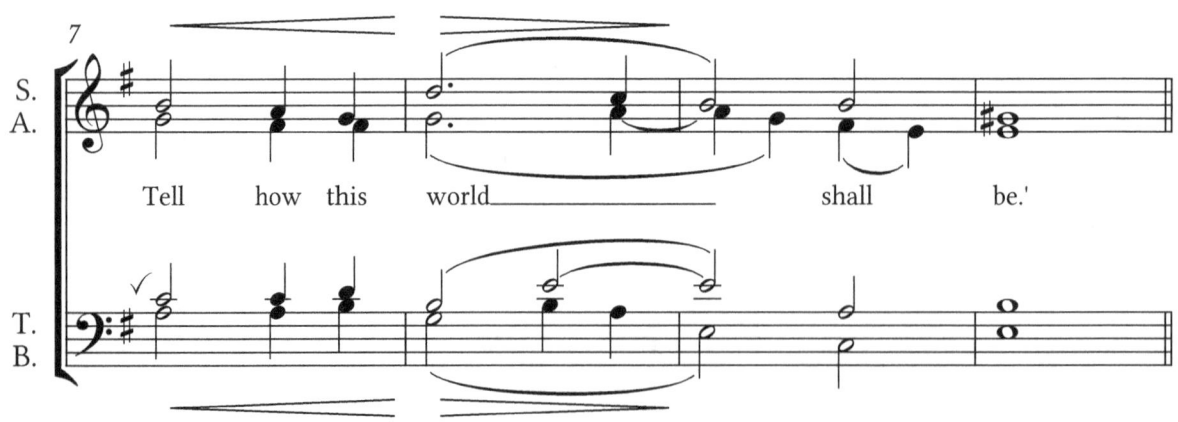

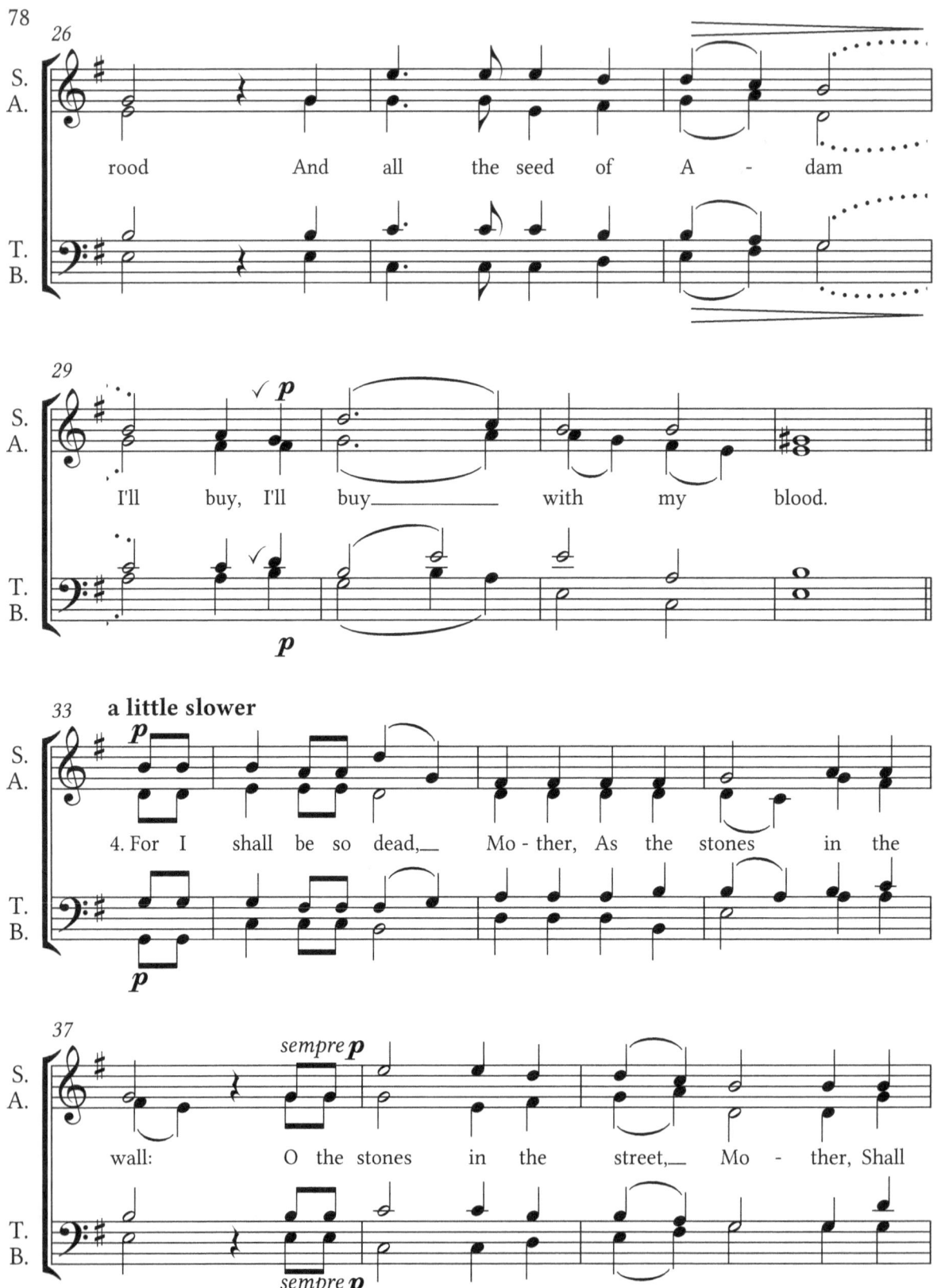

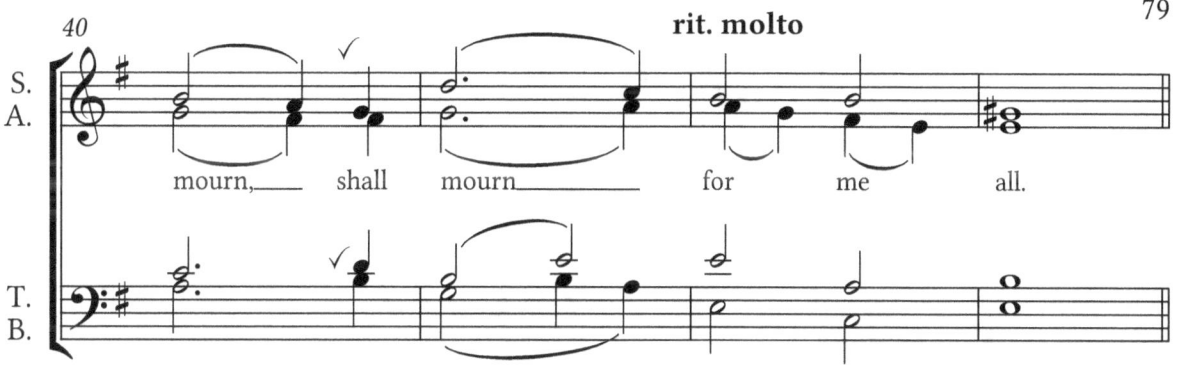
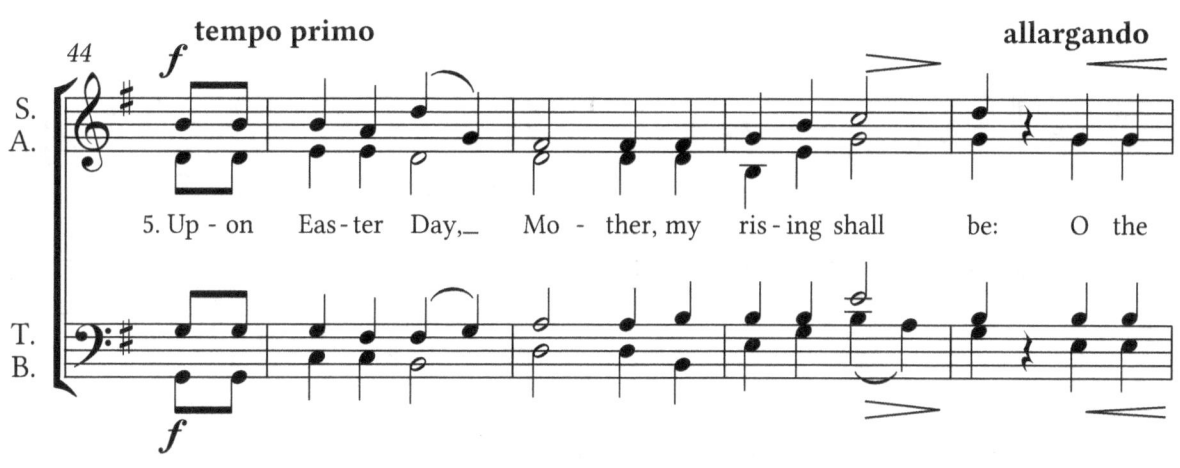
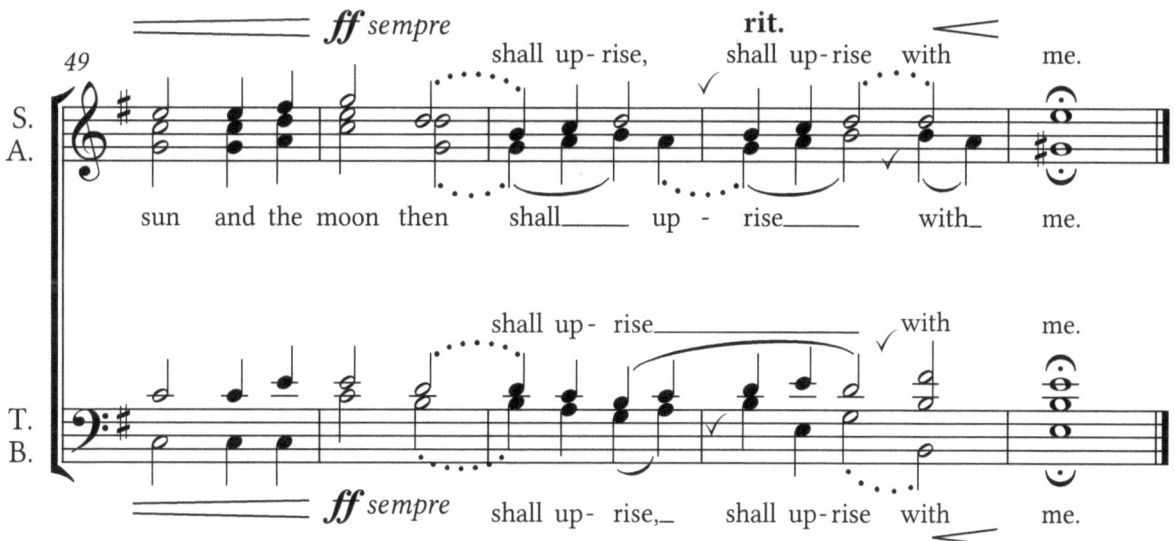

For Alexander Campkin and the Oxbridge Singers

Longfellow's Carol

Henry Wadsworth Longfellow (1807-1882) Andrew Henderson (b1984)

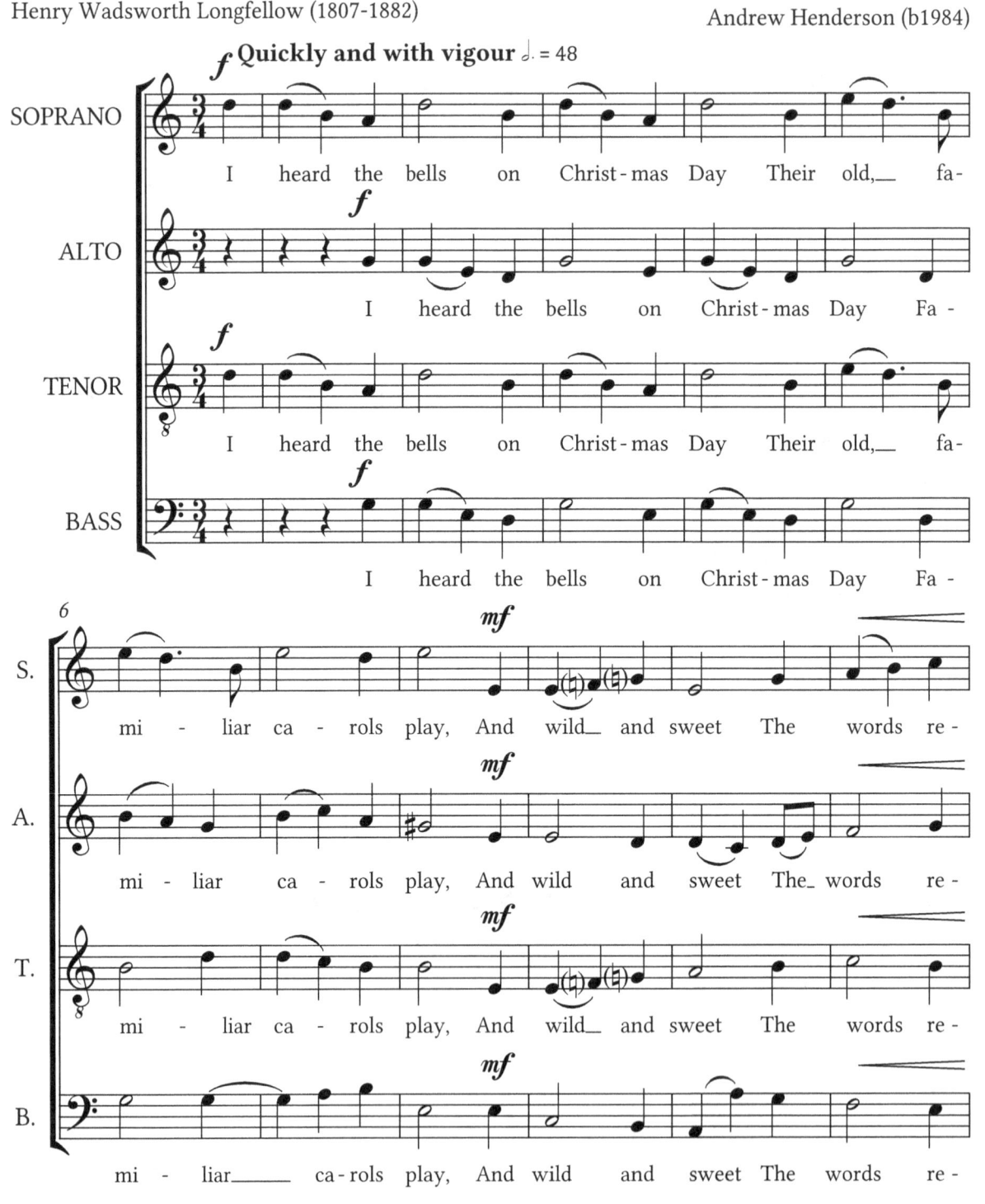

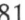

S.
of___ all Christ-en-dom had rolled a-long The un bro-ken
volved from night to day, A voice, a chime, A chant sub-

A.
bells__ of Christ-en-dom had rolled a-long_The un bro-ken
volved from night to day, A voice, a chime, A chant sub-

T.
of all Christ-en-dom had rolled a-long The un bro-ken
volved from night to day, A voice, a chime, A chant sub-

B.
bells__ of Christ-en-dom had rolled a-long_The un bro-ken
volved from night to day, A voice, a chime, A chant sub-

S.
song Of peace on earth, good-will__ to men!____
lime Of peace on earth, good-will__ to men!____

A.
song_ Of peace on earth, good-will to men!____
lime_ Of peace on earth, good-will to men!____

T.
song Of peace on earth, good-will__ to men!____
lime Of peace on earth, good-will__ to men!____

B.
song Of peace on earth_ good-will to men!____
lime Of peace on earth, good-will to men!____

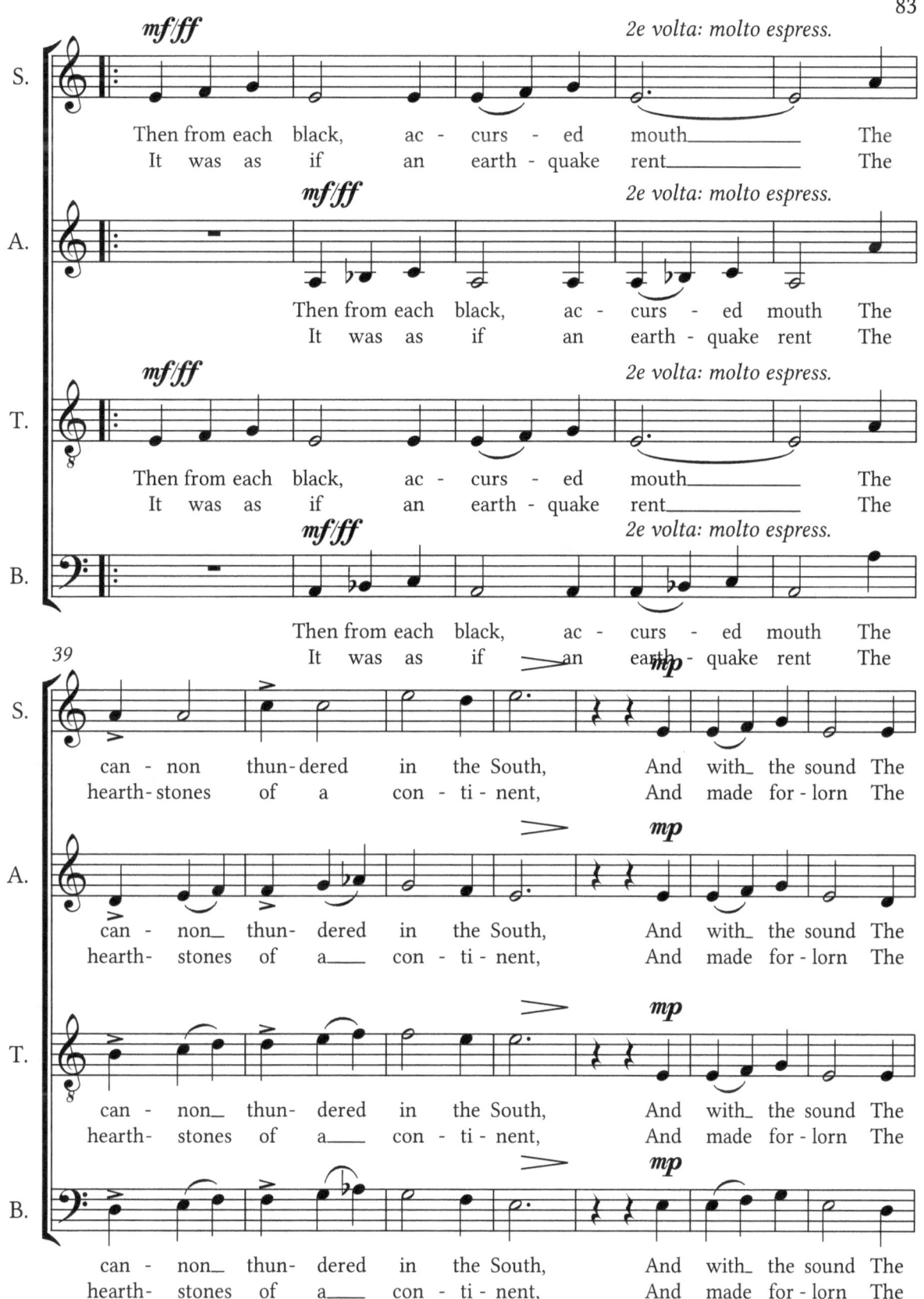

S. ca - rols drowned Of peace on earth, good - will to men!
house - holds born Of peace on earth, good - will to men!

A. ca - rols drowned Of peace_____ to men!
house - holds born Of peace_____ to men!

T. ca - rols drowned Of peace on earth, good - will to men!
house - holds born Of peace on earth, good - will to men!

B. ca - rols drowned Of peace_____ to men!
house - holds born Of peace_____ to men!

mf **Slower**

S. And in des - pair I bowed my head; "There is no peace on earth," I

A. And in des - pair I bowed my head; "There is no peace on earth," I

T. And in des - pair I bowed my head; "There is no peace on earth," I

B. And in des - pair I bowed my head; "There is no peace on earth," I

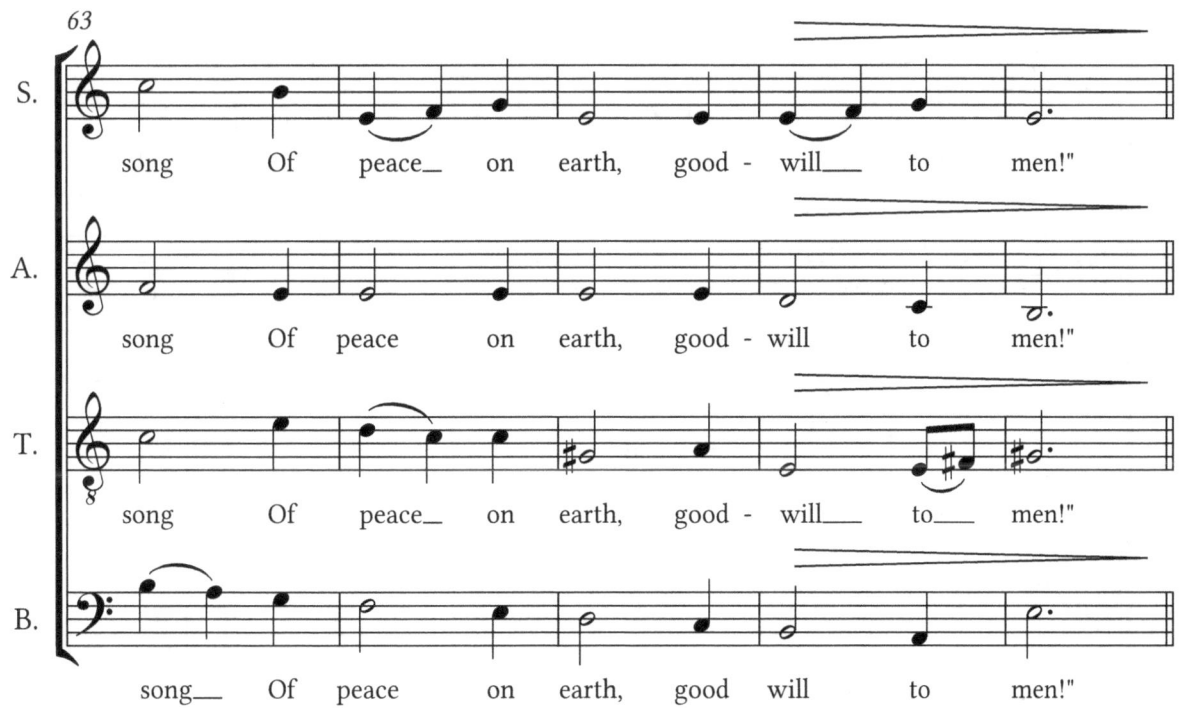

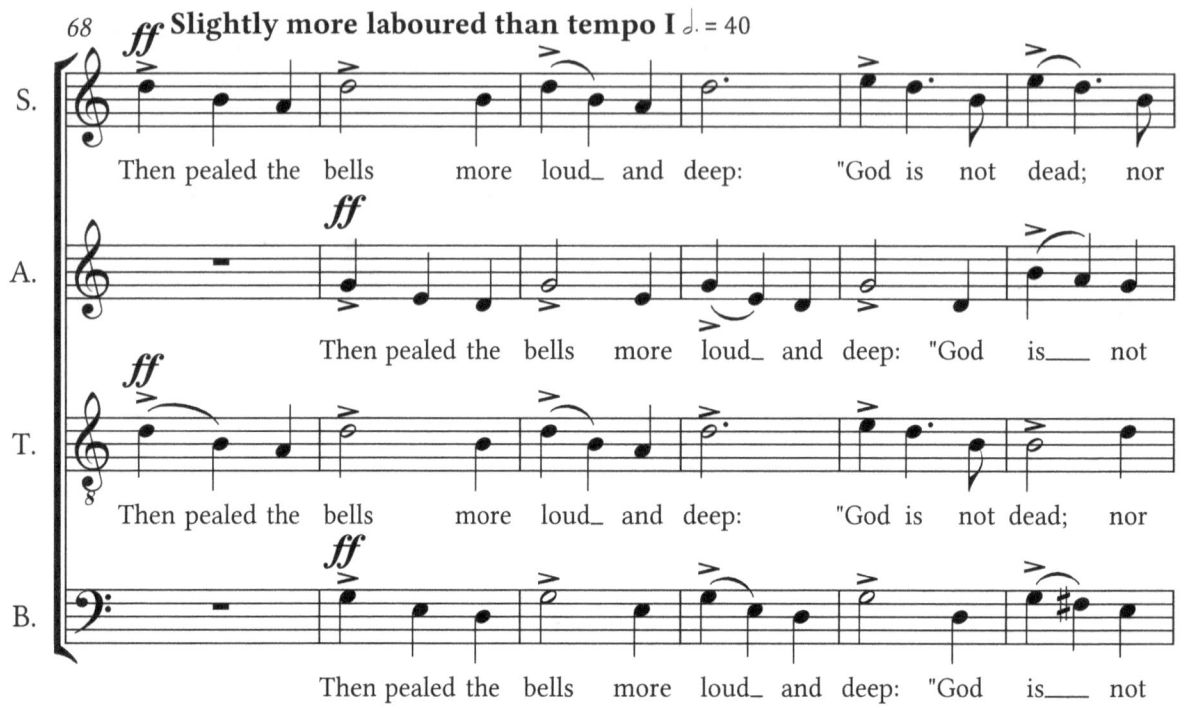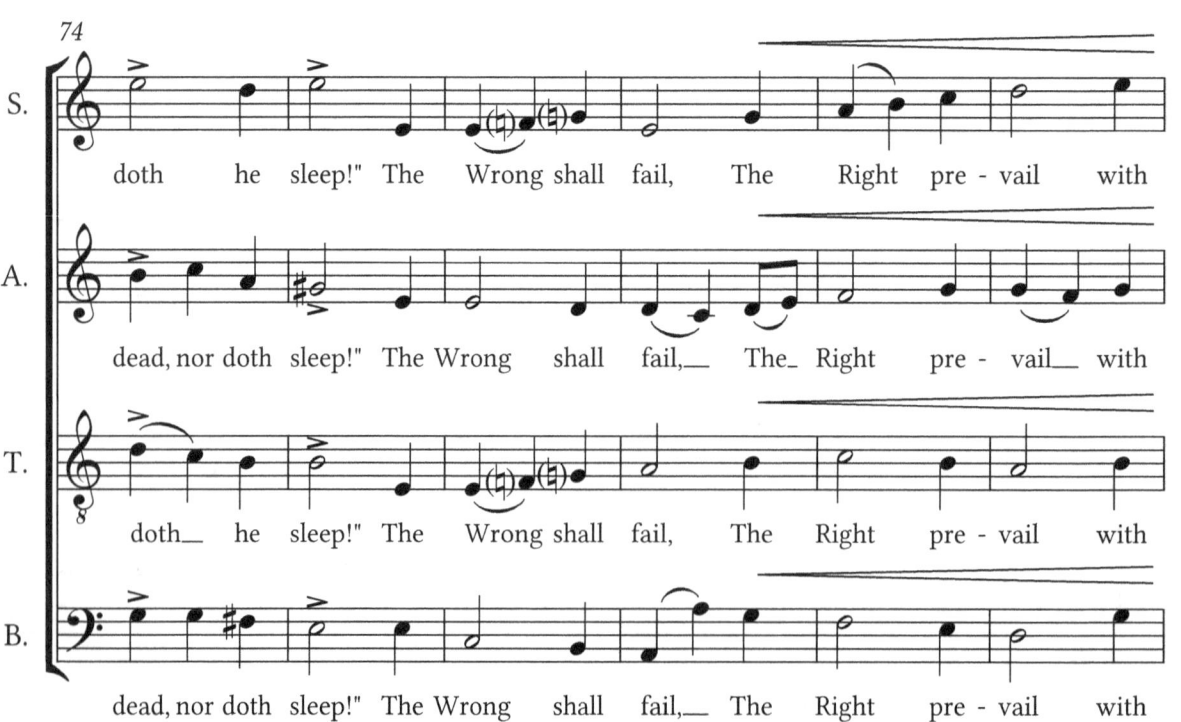

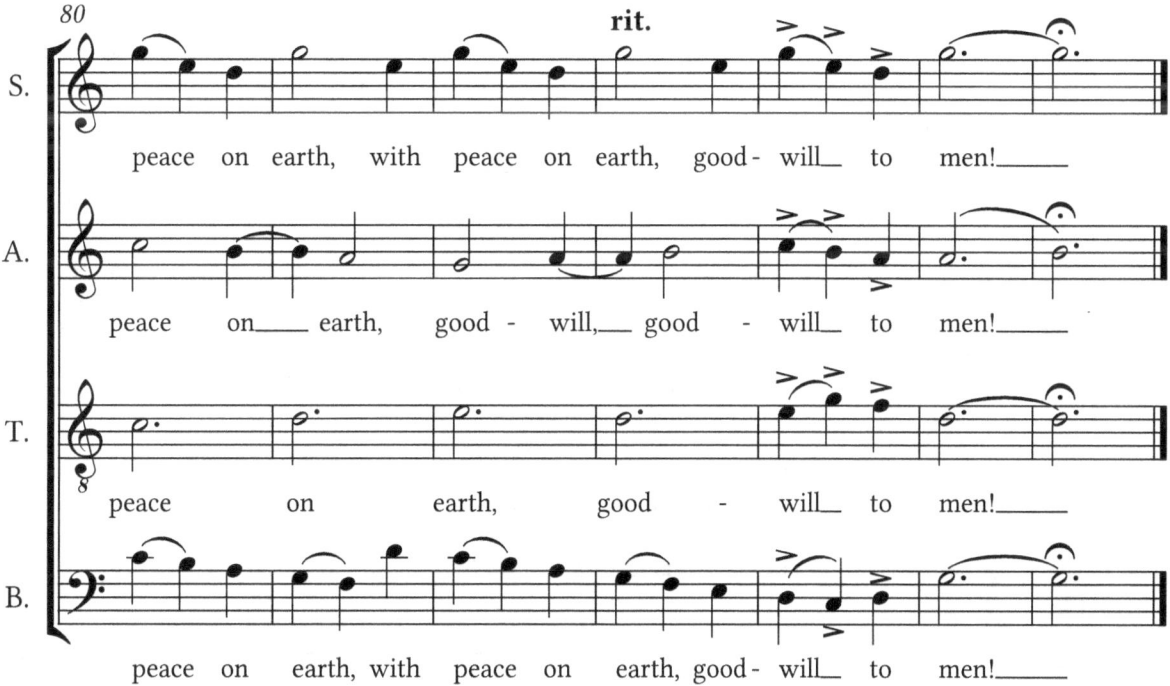

88

for David Gajadharsingh
Gaudete

Piae Cantiones, 1582

Piae Cantiones, 1582
arr. Andrew Henderson (b1984)

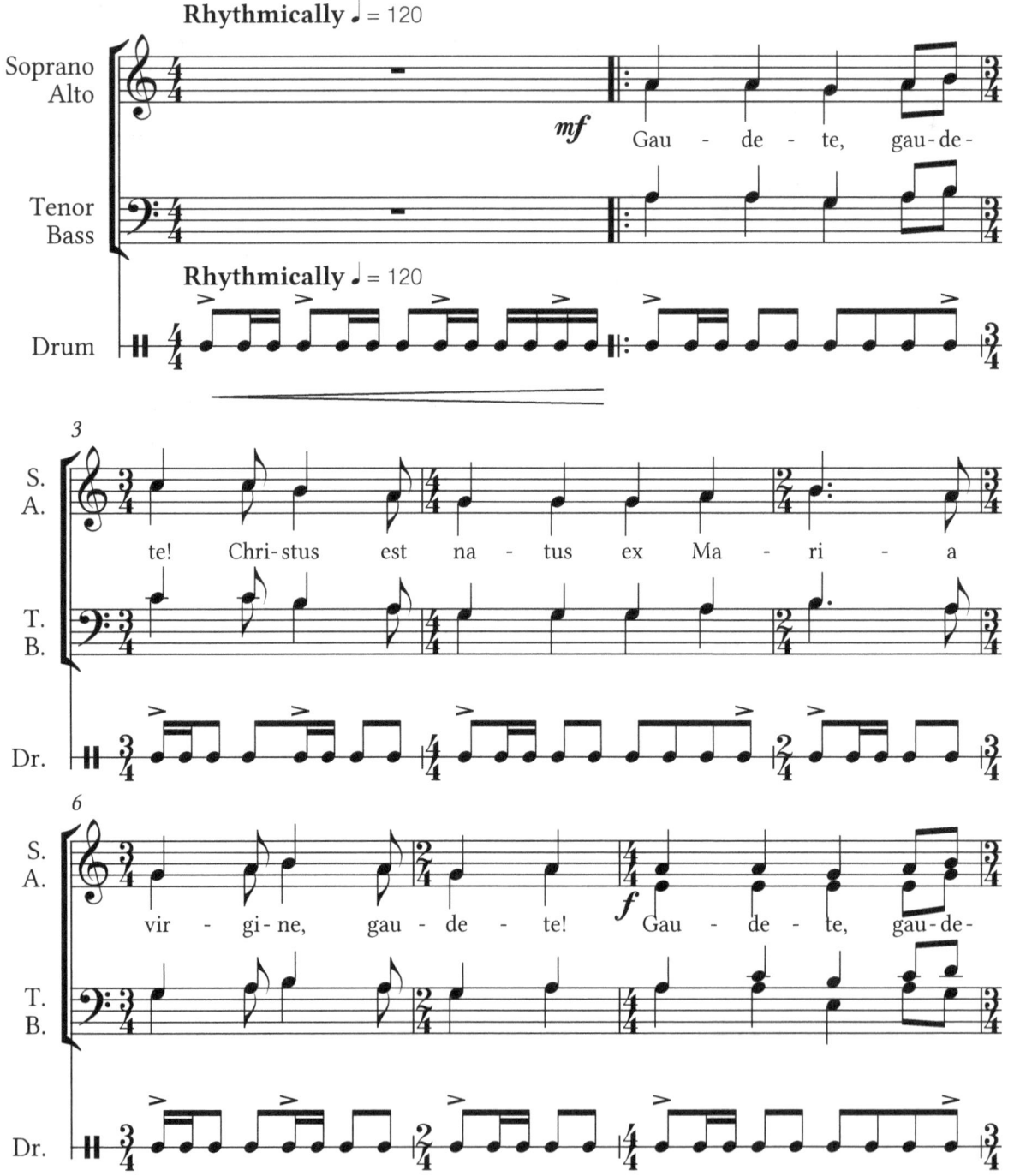

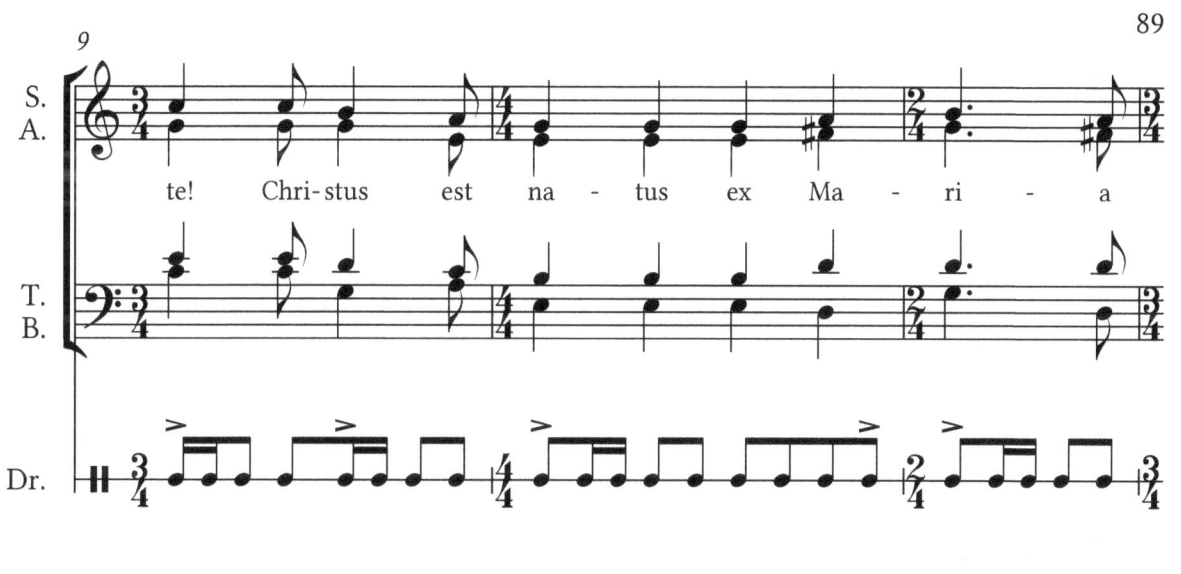
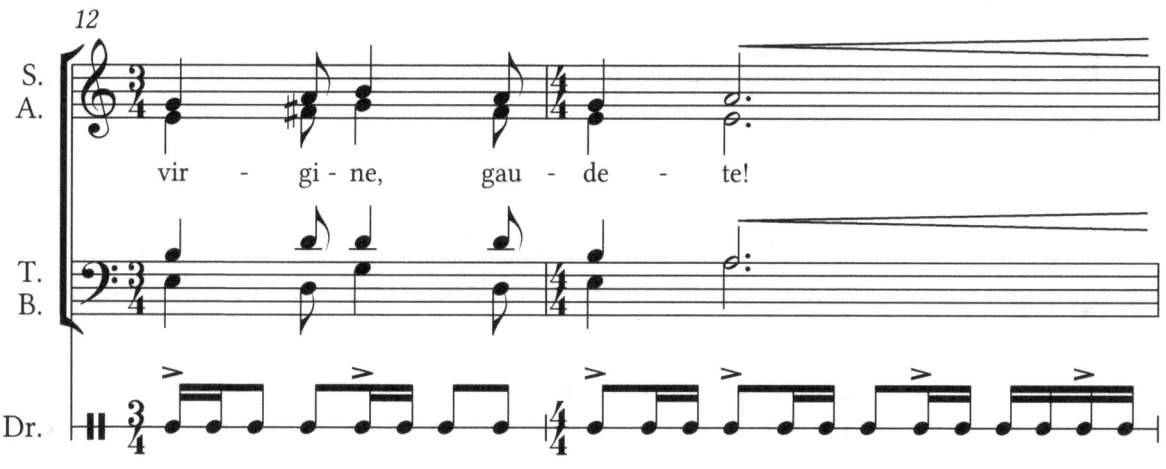
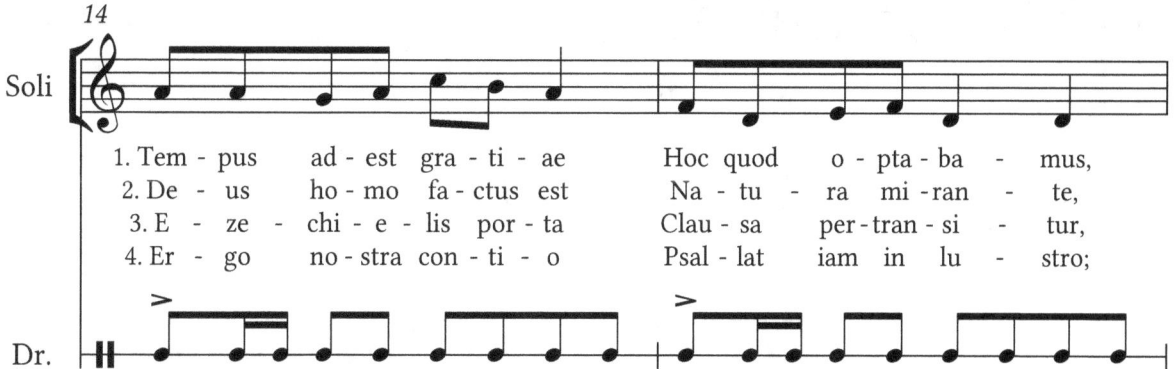

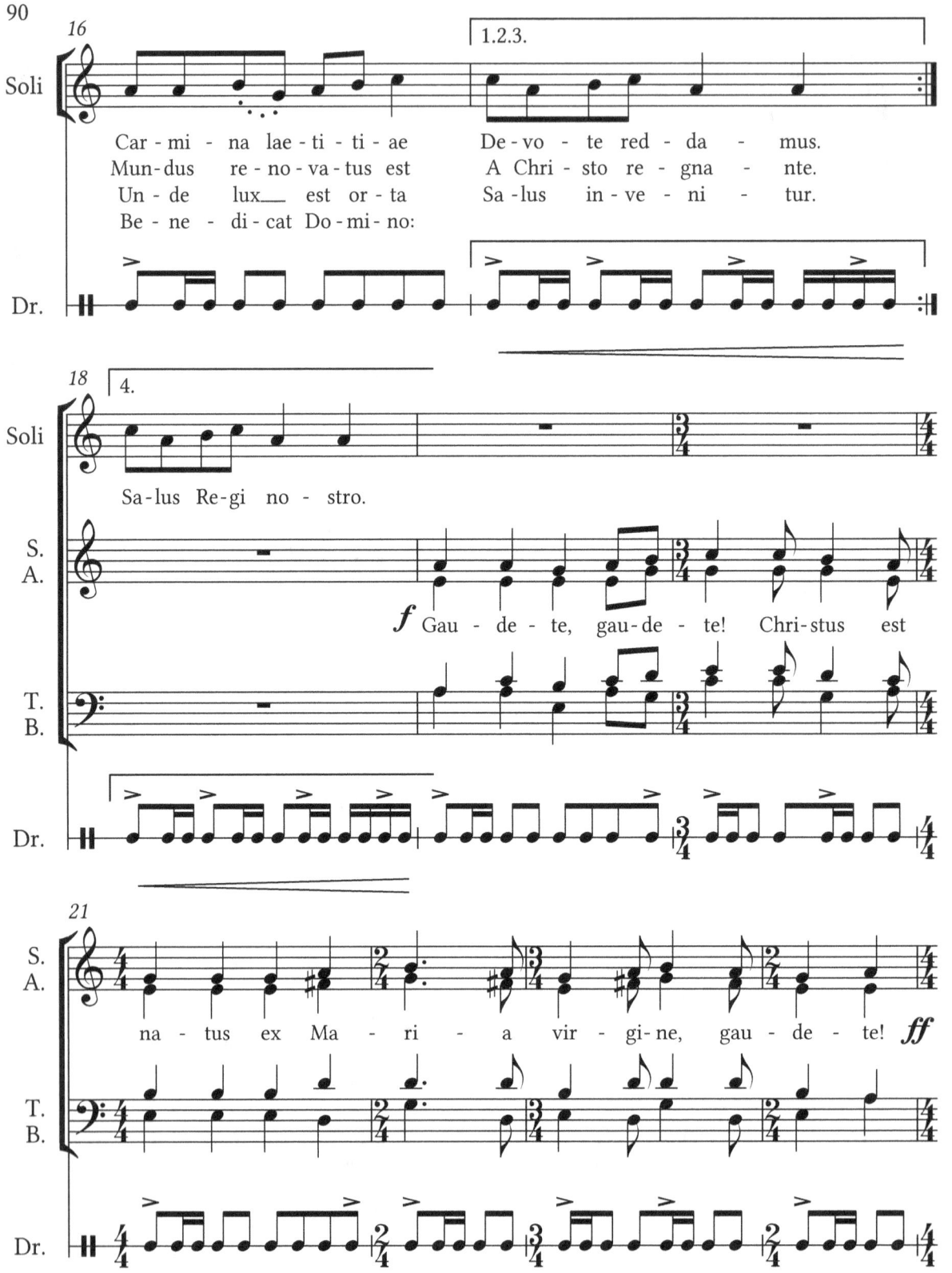

www.ingramcontent.com/pod-product-compliance
Lightning Source LLC
Chambersburg PA
CBHW080944170526
45158CB00008B/2367